MODERN COLORED PENCIL

A playful and contemporary exploration of colored pencil drawing

Chelsea Ward

Quarto.com

© 2019 Quarto Publishing Group USA Inc.
Artwork and text © 2019 Chelsea Ward

First published in 2019 by Walter Foster Publishing, an imprint of The Quarto Group.
100 Cummings Center, Suite 265D, Beverly, MA 01915, USA.
T (949) 380-7510 **F** (949) 380-7575

Walter Foster Publishing titles are also available at discount for retail, wholesale, promotional, and bulk purchase. For details, contact the Special Sales Manager by email at specialsales@quarto.com or by mail at The Quarto Group, Attn: Special Sales Manager, 100 Cummings Center, Suite 265D, Beverly, MA 01915, USA.

ISBN: 978-1-63322-814-6

Digital edition published in 2019
eISBN: 978-1-63322-815-3

Acquiring & Project Editor: Stephanie Carbajal

TABLE OF CONTENTS

INTRODUCTION .. 4

Supplies ... 5

Erasing Tools & Techniques................................ 12

Mark-Making Techniques................................... 14

Exploring Color .. 19

Blending & Burnishing 25

Layering to Build Dimension 29

Working on Toned Paper 33

SEEING & USING PATTERNS.......................... 36

Looking for Patterns.. 37

DRAWING EVERYDAY LIFE............................. 48

Fruits & Veggies.. 49

Glass Objects ... 59

Desk Supplies... 63

Plants ... 66

Interior Scene... 70

DRAWING ARCHITECTURE & LANDSCAPES....................... 74

Windows.. 75

Doors.. 83

Landscapes ... 96

DRAWING ANIMALS... 105

Gesture Drawing.. 106

Cats & Dogs .. 107

Birds.. 113

Giraffe .. 115

FIGURE STUDIES .. 119

Skin Tones & Hair Color...................................... 120

Figure Proportions .. 121

Gesture Drawing.. 123

CLOSING THOUGHTS....................................... 126

ABOUT THE ARTIST... 127

INTRODUCTION

When we first learn to draw, it's likely that those first few scribbles are done with colored pencils. Colored pencils are a unique medium because their use spans so many age demographics and skill levels. From the youngest of artists to the more well-seasoned, colored pencils are a versatile material that yields colorful results, as well as an enjoyable process!

Unlike oil paints, which can take years to master and involve an array of chemical-ridden accessories, colored pencils are very accessible. With just a piece of paper and a few colors, you can create gorgeous drawings in a variety of styles, ranging from loose studies to cartoonish sketches, realistic renderings, and even an artfully designed coloring page.

Colored pencils are also relatively portable. Paints require easels and space for a palette and water jar, whereas colored pencils can be used in the car, on a plane, at a coffee shop, or right at home on your couch! With colored pencils, it's easy to make your studio wherever you are in that moment.

In *Modern Colored Pencil,* we'll break down the variety of supplies you can use when drawing with colored pencils: different types of pencils and papers, and what to look for when you're shopping for your first box of colored pencils. We'll also cover more in-depth information, like the color wheel, blending, and erasing, as well as how to use this knowledge to create more realistic illustrations.

Once we cover the basics, you'll be ready for some step-by-step lessons and exercises. We'll work through useful exercises to practice these new skills and incorporate them into your drawings. All drawing examples are broken down step by step and cover a variety of drawing subjects—everything from nature studies and everyday life to architecture, people, and animals.

By the end of this book, I hope you'll be inspired to document the world around you with colored pencils. Now, time to sharpen those colored pencils and start drawing!

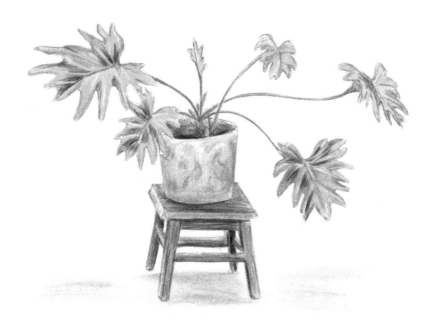

SUPPLIES

One of the wonderful things about working with colored pencils is that you can get started with just a handful of supplies. It doesn't take much to create colorful and expressive drawings. As you gain more knowledge and confidence with your tools, you can expand your arsenal to fuel your coloring adventures!

COLORED PENCILS

The most important supply is, of course, colored pencils! But where to start? It can be overwhelming going to an art store and seeing all the different brands and options available. Which set is best for your purpose and skill level? Here's a quick breakdown of what to look for when shopping for colored pencils.

Wax vs. Oil

Colored pencils consist of colored pigment with a binder, shaped and contained in a wooden shell. Manufacturers use different materials and mixtures for their binders, but the most common are wax- and oil-based binders. Some manufacturers use both but in different ratios compared to other manufacturers.

Wax-based

Colored pencils with a higher wax content are harder pencils. They can sometimes be more difficult to blend or erase, but they're also the most common type of colored pencils on the market today. You can still create rich layers of color with wax-based pencils, but the richness is different compared to oil-based pencils.

Oil-based pencils are softer and therefore easier to blend, due to their more greasy, richer quality. They are also easier to erase when applied in light layers on the paper. Both types can give you beautiful and colorful results!

Oil-based

Artist-Quality vs. Regular

Artist-quality pencils are more expensive than regular colored pencils, but the quality of your pencils will also influence the quality of your drawings. Artist-quality pencils contain more pigment and less binder, giving your drawings richer, more vibrant color. In the sample swatches here, notice how the artist-quality purple pencil adds richer pigment to the paper than a regular colored pencil.

Regular colored pencils—the kind you used as an elementary-school student—contain more binder and less pigment. This doesn't necessarily mean your drawings won't be colorful! You can still create gorgeous drawings with regular colored pencil sets, but you'll find that it's harder to seamlessly blend these pencils.

Artist-quality sets usually come in larger packs with more color choices, which can be a bigger investment from the start. Fortunately, you can still blend many shades of colors from regular colored pencil sets, so don't feel the need to invest in an expensive set of pencils when you're just getting started!

Artist

Regular

Colored pencil

Watercolor pencil

Colored Pencils vs. Watercolor Pencils

Colored pencils are naturally water-resistant, due to the waxy ingredients in the pigment binders. Watercolor pencils are exactly like they sound: water-soluble! These pencils lay down color on paper like a regular pencil, but with a quick stroke of water from a paintbrush, you can spread the pigment around like watercolor paint! These can be a lot of fun when working on backgrounds, or even for building up layers in your drawings. We'll discuss when and how to use watercolor pencils in more detail later in this book.

Pack Size

Colored pencils are sold in a variety of pack sizes. From basic sets featuring just primary and secondary colors to full arrays with 100 colors, you have multiple options from which to choose! The color scales shown here demonstrate the difference in variation between an 8-color pack and a 20-color pack.

Larger packs are wonderful, but they can come with a hefty price tag! When you're getting started, don't feel pressured to buy the giant packs (unless you really want to), because you can still blend and combine the colors in smaller packs and achieve a wider array of colors.

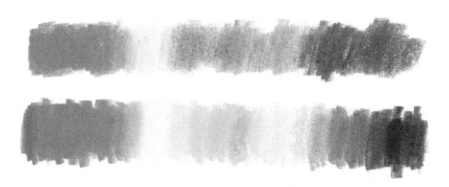

Color Variation

The same colors in different brands can also vary in appearance. This color spectrum chart shows the three primary colors (red, yellow, and blue) from four different brands of colored pencils. You can see that each is slightly different in shade, richness, and opacity, as well as blending capability.

This isn't necessarily bad. Some drawings may require lighter layers, which call for using harder pencils to more easily control the amount of color you add. Other drawings require the super-rich and opaque layers of color you can achieve with softer pencils. Softer pencils can also be trickier to use in tight spots that require lots of detail, so there may be areas within the same drawing where you need both hard and soft pencils.

Fortunately, colored pencils are relatively affordable, so feel free to test out a variety of brands to see which you like best! Some brands sell individual pencils so that you can test a variety of colors before committing to larger packs.

PAPER

Look for paper that has *tooth*, or texture, to grab the pigment. Textured paper allows you to add multiple layers of color to your drawings. Regular printer paper doesn't have much tooth, but you can use it for simple drawings without many layers. Many brands make their own papers specifically for colored pencil art; these are sold in single sheets and drawing pads.

Starting with white paper is a good idea, especially when you have a new pack of colored pencils. A blank slate allows you to see the full range of colors you can create, without the paper color influencing the hues. You can also practice blending and learn which color combinations you like best.

Once you get the hang of your pencils, it's fun to explore drawing on toned or colored paper! Toned paper gives you a colorful base upon which to build layers and can make a drawing feel more dynamic. Don't be afraid to go dark either!

Toned paper often comes in pads or sketchbooks, but you can also buy large individual sheets that can be trimmed into other sizes. You can even trim them down and glue the pieces into your regular sketchbooks for drawing on the go!

SHARPENERS

Most colored pencil brands make their own sharpeners—and not just to tempt you to buy more of their products! Colored pencils are often made to lock in the cores, meaning that the color inside the wooden shell has ridges to keep it from sliding out if it breaks. These ridges also keep the core in place while it's being sharpened. Regular pencil sharpeners might not sharpen well and can break the pencil cores. While it may seem silly to buy the branded sharpener, they're created to sharpen those particular colored pencils to the perfect tip without wasting your precious materials. Electric sharpeners also work well, but it can be hard to see how sharp your pencil is getting, and you may over-sharpen and waste more of the pencil than you realize!

ERASERS

A good soft eraser is a must! Regular pink erasers are great—even the kind on the top of a regular #2 pencil. As long as they're soft and not dried out, they can eliminate some of your stray marks. But it's also good to have other types of erasers on hand. Kneaded erasers are great because you can lift up layers of colors from the page more gently. Click erasers, which are similar to mechanical pencils, can be shaped to fine points so you can erase light lines or tiny, hard-to-reach areas. Pencil erasers, which are pencils with eraser cores, can also be sharpened to fine tips.

SKETCHING PENCIL

Like any other medium, you also need a regular old pencil! While it can be exciting to get started on a colored pencil drawing, it's always best to do your first sketches with a drawing pencil because it's easier to erase. Colored pencils are fairly permanent and can stain the paper with pigment. You can also use a regular pencil to map out where the highlights and shadows will be in your drawing. I like to use mechanical pencils with soft lead so I always have a fine point with which to draw.

BLENDING TOOLS

Blenders are used to blend layers of colors and eliminate pencil strokes. Many manufacturers carry their own blending pencils made with just binder and no pigment. These are great, since you can sharpen them to blend in the narrow areas of your drawings.

You can also use blending stumps or tortillons! These are tightly rolled pieces of paper that gently blend colors in small or large areas. They come in a variety of sizes. In a pinch, you can also use a tissue wrapped around your finger to blend.

Using solvents and a brush is another option. (See page 28 for more details.) This is better for blending larger areas, and these supplies are available at most art stores.

The final—and perhaps most important—things you need when working with colored pencils are time and patience. Be patient and kind to yourself as you learn these new skills. Colored pencils can be a quick medium to pick up and play around with, but with a little time and lots of patience, the novice can become the colorful master.

CARING FOR YOUR COLORED PENCILS

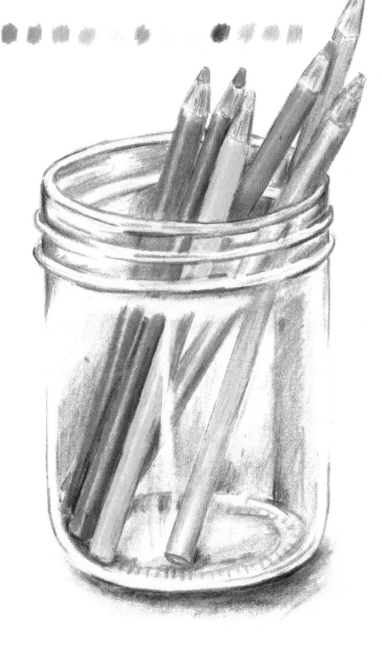

Once you have your brand new set of colored pencils, you'll want to take care of them to ensure they're useful down to the last inches! One of the best ways to care for your pencils is taking care not to drop them. Dropping a single pencil or a whole box can break the cores. If the core breaks, it may slide out during usage and become wasted lead. Some brands have anti-breakage cores, which are designed to resist breaking or sliding out. Just to be safe, always carry and transport your pencils with care. I like to keep mine upright in clear jars on my desk so I can easily find the color I want.

When sharpening your pencils, use the recommended sharpeners for that brand, or at least a sharp sharpener. To get smooth, sharpened points, twist your pencils in full circles instead of back-and-forth jerking motions. Always store your pencils with the points upward to keep them sharp while they're waiting to be used!

PENCIL COMPARISON

Colored pencils come in a variety of types, some of which are better suited to certain drawings than others. When getting started, it's good to have an understanding of each pencil type's capabilities.

Wax-Based

Wax-based pencils contain more wax, which can have some benefits. Having more wax in the core means these pencils are harder, like regular drawing pencils, which can be more difficult to erase. They can still be blended, but not as easily as oil-based pencils. Each brand has its own special mixture of pigment and wax, so even if you find one brand of wax-based pencils that you don't like, you may like another!

Oil-Based

Oil-based pencils have a softer core and contain an oilier binder with less wax. Soft pencils can help with layering and blending colors. Since they're much softer, you can sometimes erase lighter layers more fully. Oil-based pencils tend to be more expensive, but they're usually worth the investment. Most artist-grade colored pencils are oil-based.

Watercolor

Watercolor pencils are a great option to keep on hand, even to use in conjunction with wax- or oil-based pencils! Since they're water-soluble, you can blend multiple layers with just a brush and a few strokes of water. When working on larger pieces, this comes in handy for covering big, empty areas with color. In addition to being able to blend colors using only water, you can also layer more shades, texture, and fine details on top of your pencil washes when they're dry.

ERASING TOOLS
& TECHNIQUES

Mistakes happen! A stray mark or an incorrectly placed shadow is not uncommon when you're just getting started. Erasing these marks can be incredibly tricky, since colored pencils stain the paper with pigment. Luckily, there are ways to lessen their visibility so you can layer over them.

Erasing too vigorously can shift your paper, wrinkle it, or even tear it if you're not careful. Always erase gently and slowly.

Different erasers are better suited for different erasing jobs. Depending on how big the mark is or where it's located in your drawing, you may want to pick one of the following erasers.

Kneaded Eraser

Kneaded erasers can lift color off your page, but they can also be molded into shapes that are more conducive for different erasing situations. You can rub them across your drawing like any other eraser, but they're best suited for lifting patches of color and lightening a general area. You can also use kneaded erasers to add textured highlights.

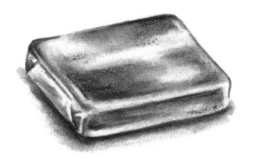

Unwrap your kneaded eraser and squish a corner so it's slightly flat. Using your fingers, press this squished area over the part of your drawing you want to lighten again and again until you reach the desired lightness. You can also use these marks to create interesting textures. Once it's lightened enough, you can add color back into your drawing as layers.

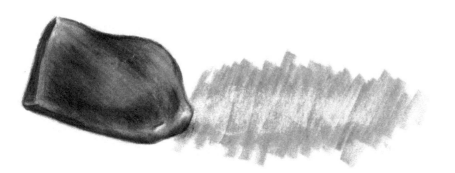

Need to clean your kneaded eraser? Grab a piece of scrap paper and press the dirty spots of the eraser onto the paper to transfer the leftover pigment to the paper!

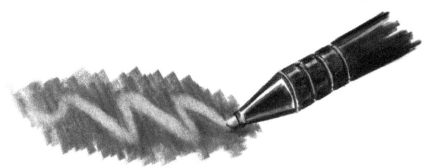

Pen & Pencil Erasers

Sometimes you need to erase a tiny portion of your drawing or want to pull out narrow or tiny highlights. In these instances, a pencil eraser or eraser pen is perfect! Pencil erasers have a core made of eraser, so you can sharpen the end to a perfect point. Eraser pens (shown) click more eraser out with every press at the top. You can buy more eraser cores to replace them when you run out. These can also be shaped into points for fine, detailed highlights.

These erasers can also get dirty, which may be problematic when you're erasing in a light area. Grab a piece of scratch paper and rub away any dirty layers to avoid transferring dark colors to your light layers.

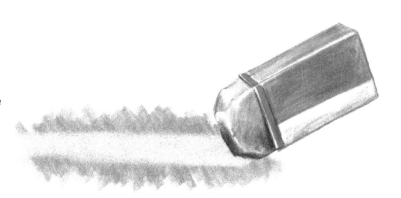

Polymer Eraser

While I love good old-fashioned pink erasers, they can dry and harden over time. My go-to erasers for stray marks or wider areas of color that need to be lightened are Hi-Polymer® erasers because they are soft and gentle. You can even take off the protective plastic and cardboard sleeve, lay the eraser on its widest side, and rub across a large area of your drawing to lighten up big areas all at once.

These can also get dirty over time. Just grab a piece of scrap paper and rub away the dirty layers to reveal a clean, white surface.

PREVENTING ERASER MOMENTS

To avoid erasing, start with a regular, soft-leaded pencil and plan your drawing out. Make sure your drawing is exactly how you want before you add color. This includes checking the scale and proportions, and even planning where the highlights and shadows will be.

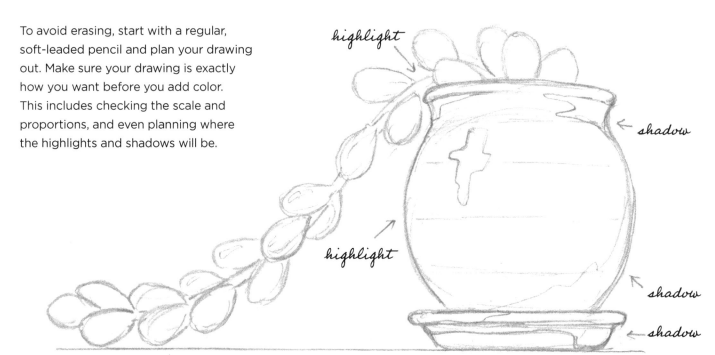

MARK-MAKING TECHNIQUES

When drawing with colored pencil, mark-making has many different purposes. Your marks can build texture, shadows, and layers; convey direction; and help a two-dimensional drawing look more lifelike and three-dimensional. In these two examples, you can see the difference that just one more layer of mark-making has in making a piece look complete and realistic.

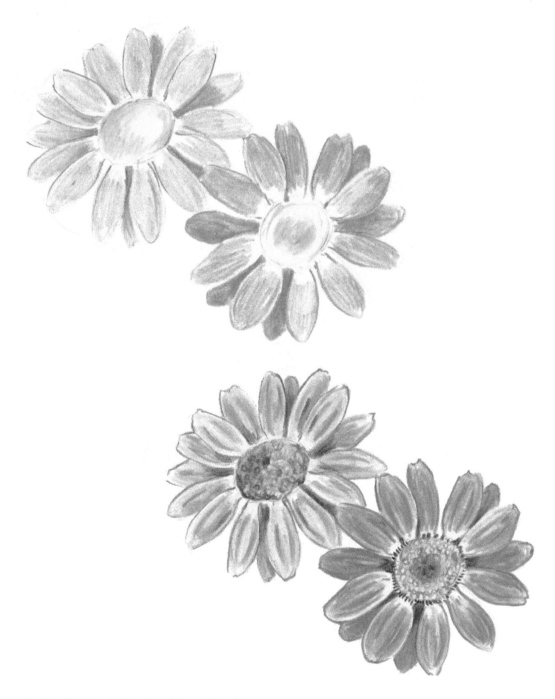

There are so many different ways to make your marks across the page. From crosshatching and circles to continuous scribbles and hatch marks, the options are endless! For a quick exercise, draw a bunch of 1-inch squares on a piece of paper. Then see how many ways you can make marks!

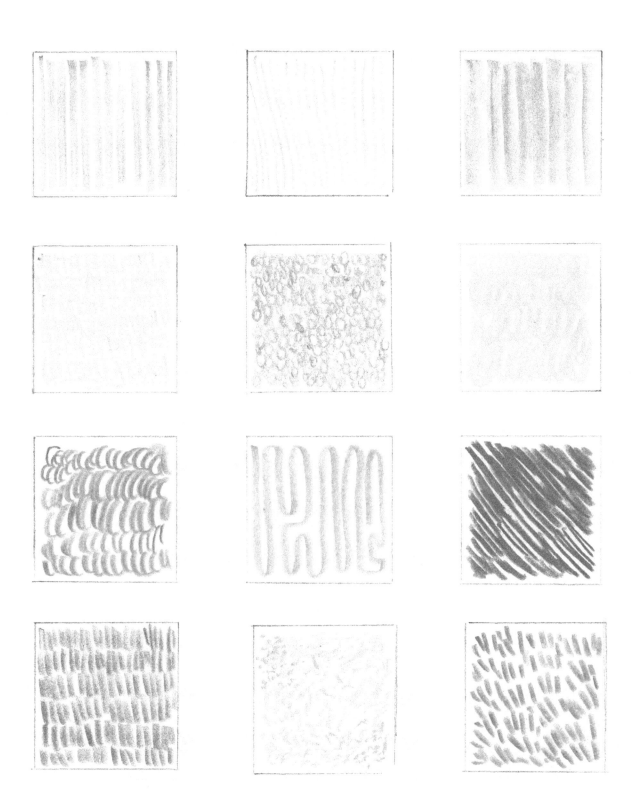

Freshly sharpened pencils create delicate lines and allow you to build up small details with lots of texture. When your pencil dulls, you can create thicker lines and different marks.

You can also use marks to build up shadows. Draw some narrow rectangles on a piece of paper and break them into intervals. Use one mark at a time to create a shading progression from light to dark. On the lighter end, apply fewer marks that are more spread apart or larger in size. With more blank paper showing, the shading appears lighter on the page.

As you move across each square, progressively build up the amount of marks. The final square should be the darkest, most filled-in square. Your marks will be the closest together and smallest in size, with the least amount of blank paper.

To test if you've made a gradual progression from light to dark, squint your eyes and look at the page. The rectangle should blur into just shading that hopefully shows a smooth progression. If a few squares look too similar, see if you can build up more shadow.

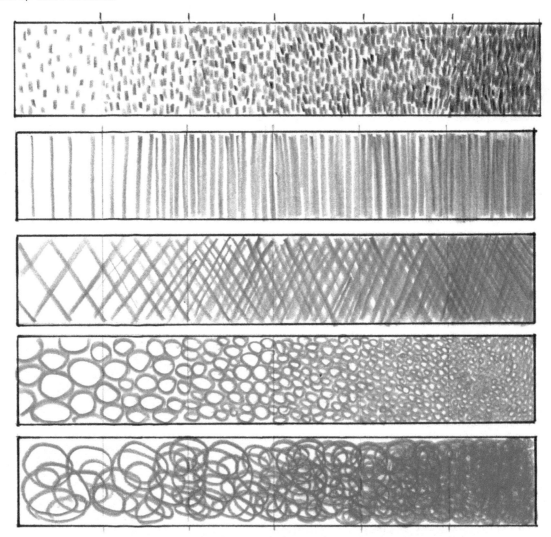

You can also use marks to convey shapes! Long lines can show shadows, but they also contour an object to convey curves and corners. Pick a shape to draw and lightly sketch it with a regular pencil. You can even grab a simple-shaped object, like an egg or an orange, to use as a reference.

Start building up the shadows with your marks, but keep in mind the direction of the marks. Do they accurately show the curve of the shape? If you're having a hard time visualizing where to put your marks to convey the shape, think of a beach ball! It may be a simple circle, but the lines that curve around it convey its round shape. Once you practice with a simple shape, try using your marks to sketch a more complex one.

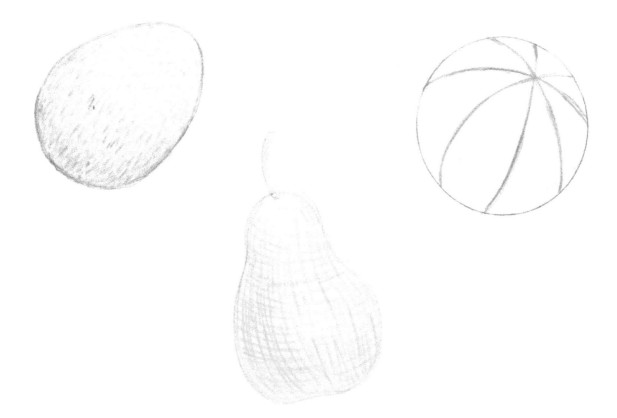

Pencils aren't the only tool you can use for mark-making. Erasers can be used to pull out highlights, but they're also helpful for adding unique marks and building lighter textures.

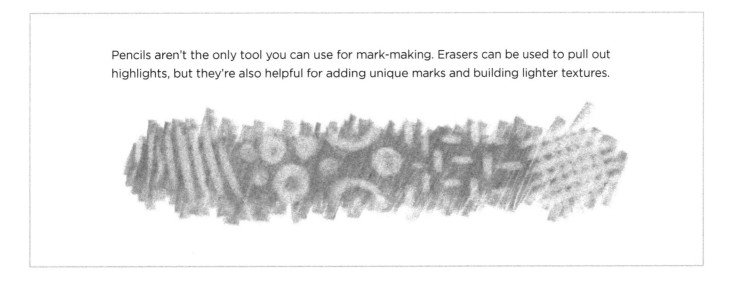

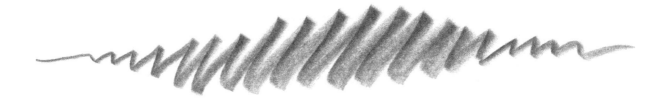

USING PRESSURE TO DEVELOP DIFFERENT VALUES

You can create an amazing variety of shades, or values, with just one pencil. Depending upon the angle you use to hold it and the amount of pressure applied, you can make many shades with a single pencil.

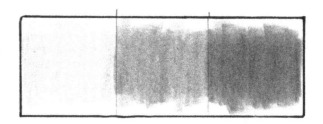

For this exercise, we want to create a smooth transition from super light to super dark. When you hold the pencil on its side with the lead flat on the paper, you eliminate pencil strokes and can create a smooth light-to-dark shift.

Draw a rectangle and divide it into three sections. On the left, start with very little pressure and make gentle strokes. Don't worry about shading in the whole square completely. As you move to the middle, apply more pressure. Be sure to also reinforce the lead of the pencil with your index finger—if you only apply pressure through the shaft of the pencil, the tip will snap! Squint your eyes as you shade the squares to make sure they change accurately and gradually from one square to the next. The square on the right should be the darkest.

Once you've practiced this small progression, draw a longer rectangle and divide it into five or six squares. Repeat the exercise with more value change between the first and last squares.

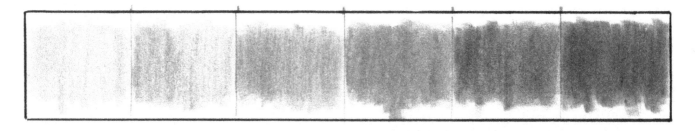

Even with just a single color, you can use these exercises to draw three-dimensional objects. Lightly sketch a circle and choose a direction for your light source. In this sketch, I pretended the light was coming from the top-right corner. This means the lightest part of the circle is closest to that corner, and the darkest part is on the opposite side. Start with a little pressure at first and slowly increase the pressure to create darker layers and shadows.

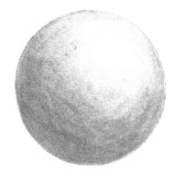

EXPLORING
COLOR

Half the fun of working with colored pencils is the vibrant assortment of colors available—especially when you start using large packs of artist-grade pencils. There are so many different shades to use in your drawings!

While it can be tempting to jump right into using your new pack of colored pencils, it's in your best interest to learn a bit about color theory so that you use your color choices, and all their potential color combinations, to your advantage.

COLOR WHEEL & COLOR THEORY BASICS

Color theory is a set of guidelines artists use to blend colors and select appropriate color combinations for artwork. Proper color theory implementation gives a piece more depth, color variation, and realistic colors. From picking colors in just one color family to working with complementary colors, color theory has so many applications in artmaking!

One of the best tools to understand color theory is the color wheel. Color wheels organize colors so you can more easily see the primary, secondary, and tertiary colors and how they relate to one another. The *primary colors* are red, yellow, and blue.

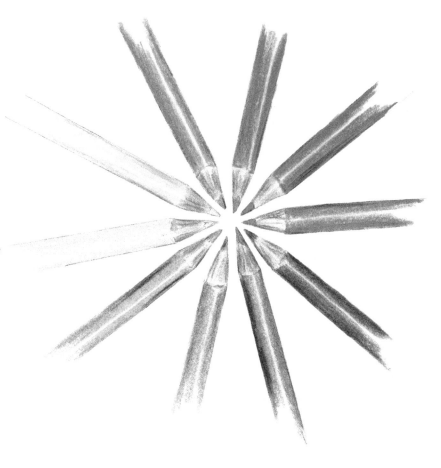

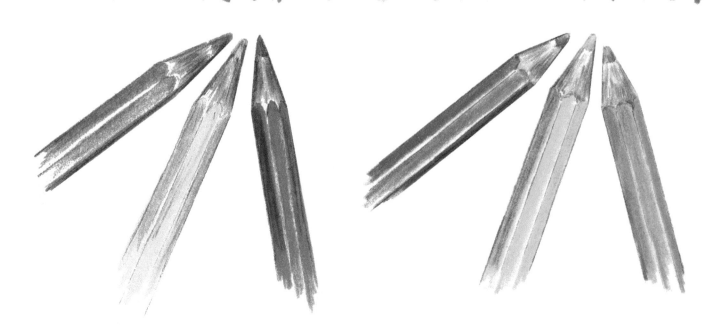

The primary colors are staples in any art medium. They cannot be created by combining any other colors.

By combining the primary colors, you can create the three *secondary colors*. Red and blue create purple, blue and yellow create green, and yellow and red make orange. While these colors may come ready-to-use in your colored pencil sets, it's a good habit to practice blending them on your own so you can achieve a wider variety of colors in your drawings.

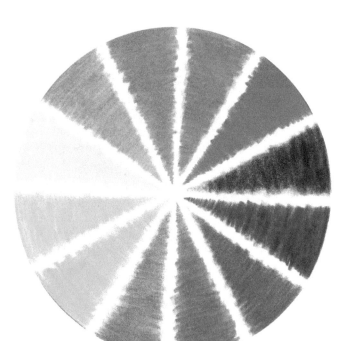

You can create *tertiary colors*, by combining a primary and a secondary color. For example, you can combine red with orange to create red-orange. Tertiary colors make a color wheel appear seamless, as one color shifts into the next hue all the way around the circle.

Knowing what colors your pencils can create through blending gives you a wider range of color to use in your artwork.

COLOR WHEEL EXERCISE

Practice creating a complete color wheel with just the primary colored pencils from your set—that means you're only allowed to use blue, red, and yellow! Don't use any of the secondary or tertiary colors in your pencil set. You can trace the color wheel template here, or just draw a small swatch of each color in a complete circle.

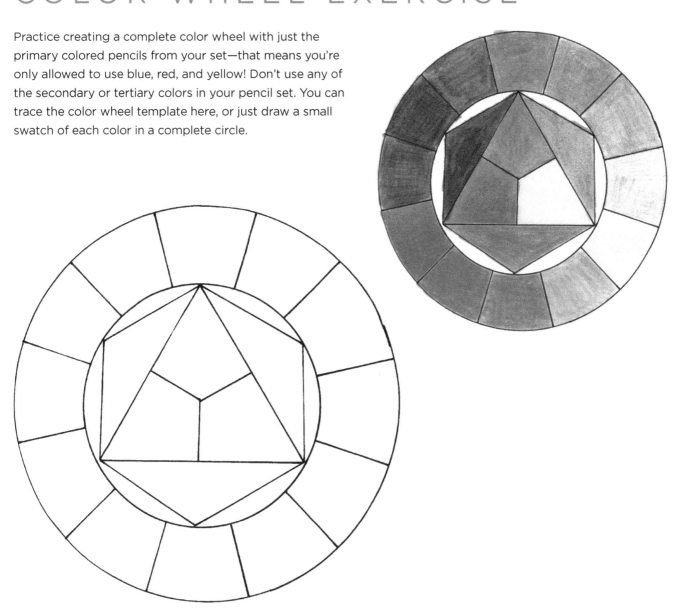

1. Fill the shapes of the center triangle with your primary colors.

2. Then use the narrower triangles along the sides of this triangle to blend the primary colors and create the secondary colors. To blend the secondary colors, layer a little of each color at a time until you reach what appears to be a 50/50 blend of each primary color. Keep in mind that these secondary colors will be different from the green, purple, or orange pencils right out of your box, and that's OK!

3. Each secondary-color triangle points to a space along the outer ring. The color of that triangle should also go in the space to which it points. Start with the primary colors first; then blend the secondary colors in their appropriate spaces.

4. Once you've colored in the primary and secondary colors on this outer ring, you'll see alternating blank spaces between these colors. This is where you'll blend your tertiary colors! Just like blending the secondary colors, apply a little bit of each color at a time until you reach the perfect middle tone between the two surrounding primary and secondary colors.

If you look at the colors that lie directly across from one another in the outer ring of your color wheel, you'll find some interesting color combinations—these colors are complementary. In a basic color wheel, with just primary and secondary colors, the complementary color pairs are red and green, blue and orange, and yellow and purple.

Using two complementary colors together gives each color a little more richness on the page. When combined in equal parts, complementary colors create a brownish shade that's perfect for shadows on objects that are either of those colors.

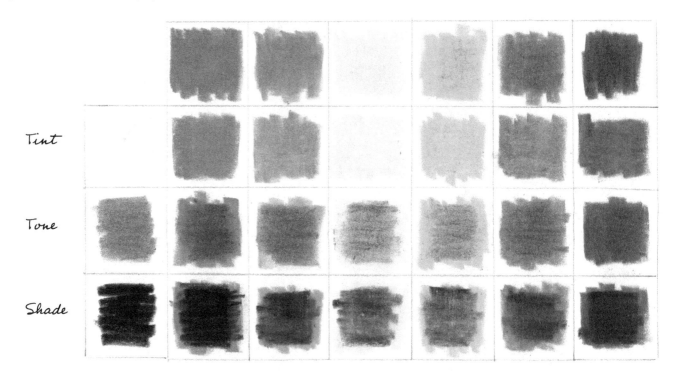

For example, the shadows on a green lime will look more realistic if you combine red with green. Same thing goes for an orange. When you add blue to the darker areas, it makes the shadows appear more realistic than if you use straight black. And if you're drawing a yellow lemon, you'll want to add some purple into those darker areas to really get those shadows to "pop."

Tint

Tone

Shade

You can also alter these colors even more by adding white, gray, or black. White changes the tint of that color, gray changes the tone, and black changes the shade. In this chart you can see how subtly or drastically these three colors can change the primary and secondary colors.

COMPLEMENTARY COLORS

Pick a color from your set—any color. Now, using your color wheel, find its direct complement. This may be easy if you have a smaller set, but it can be more challenging if you have lots of options. Do your best! Similar to the value scale exercises, practice creating a seamless shift in values, this time from one color to another. You can draw a long rectangle to help gauge your progression from dark to light and then dark again. Or, if you'd prefer, try creating a smooth transition from one color to another without a chart to guide you. If you're using a chart, make sure you have an odd number of squares. Using one color, shade the square farthest to the left as dark as possible. As you move across the page, make each square progressively lighter until you reach the center square where the shading should very light.

With your second color, shade over the center square very lightly until you have a lightly blended mix of both colors. Continue to shade progressively darker as you move to the right, filling the square farthest to the right with the darkest shade you can. You can also shade a little of each color farther along in each direction to make the shift in colors appear more gradual.

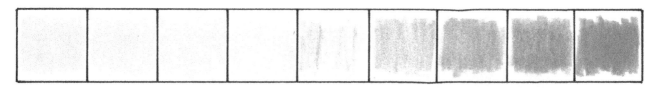

Ready to step up it up a notch? Using the first color, draw a circle and shade it like a sphere so it looks three-dimensional. Keep in mind that the side closest to the "light source" will be the lightest, while the opposite side should have the darkest shades. Once it's shaded in all the way, use the complementary color to build up the shadows even more. If you chose your complementary colors correctly, they should create a brownish tone in the shadows.

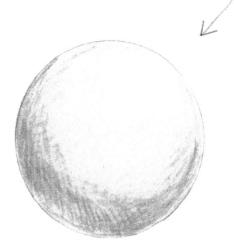

COLOR FAMILIES

Within the color wheel, you can divide the colors into color families. The simplest two families are warm and cool colors. The warm colors are yellows, oranges, and reds, while the cool colors are greens, blues, and purples. You can break the color families into concentrated colors, especially when you have a full color wheel of secondary and tertiary colors. For example, the red color family is made up of red, red-orange, red-purple, and so on.

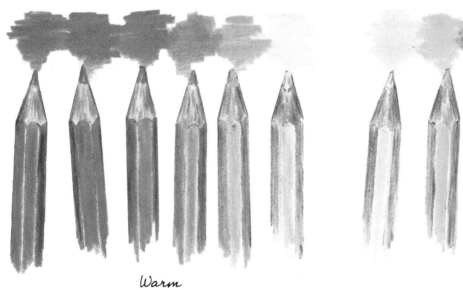
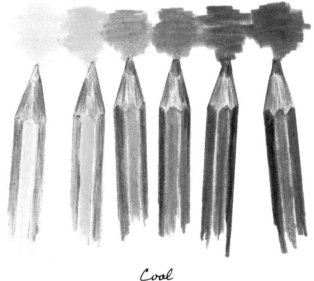

Warm *Cool*

Pick a color family from your colored pencil set. If you have a smaller set, pick warm or cool colors. If you have a larger set, challenge yourself to pick a more specific color family, such as yellow, yellow-orange, and yellow-green. Practice blending these colors seamlessly, one into the next, across your page. This can be done in square chart progressions, color scribbles, or even with marks from the mark-making exercises on pages 14 to 18. Try a few different methods, and different color families too. Blend with at least three different colors.

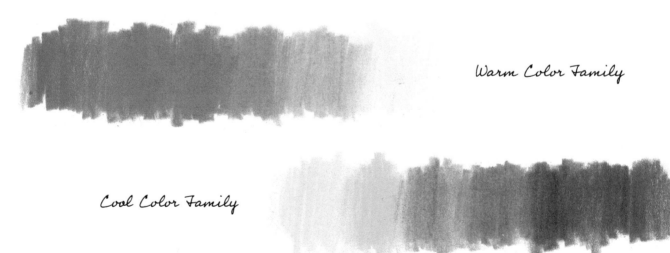

Warm Color Family

Cool Color Family

BLENDING & BURNISHING

Blending colors seamlessly from one into the next is a great skill to have when using colored pencils. It can help your drawings appear more realistic, but it's also very aesthetically pleasing to have a plane of color without any distracting pencil strokes.

There are a few ways to achieve this look in your drawings, besides just lightly layering colors on the page, including blending tools, burnishing techniques, and even solvents.

BLENDING TOOLS

Blending Stumps

Blending tools can be very useful for blending two colored pencil shades together. The most common tools you can find at art stores are blending stumps, or tortillons. These tightly rolled sticks of paper give you a soft surface to blend your colors together or blend color into the paper. These tools are also helpful if you want to fade a color out. They are affordable and often come in bulk packs of various sizes.

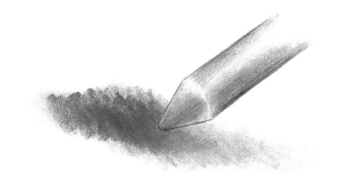

Blending Pencils

You can also find blending pencils at art-supply stores. Many colored pencil brands make these using the same binder mixture as the colored pencils, but without the colored pigment. This gives you a colorless pencil that can be used to blend colors together. Since they can be sharpened to fine tips, you can blend tiny areas or lay the lead on its side and blend larger areas of color.

No time to run to the art store? Grab a tissue, napkin, or a sheet of paper towel! Fold it into a small square or wrap it around your finger and gently rub it over the colors you want to blend.

BURNISHING TECHNIQUES

Another way to seamlessly blend colors in a drawing is burnishing. For this technique, you gradually build up the layers of your colors over and over, adding more pigment and pressing harder with each subsequent layer until you've filled the tooth of the paper. It will have a waxy, smooth appearance when complete. You can see in these three examples that with each addition of a layer of green, the drawing becomes richer and the paper tooth slowly disappears, leaving a seamlessly burnished drawing. While the first succulent looks finished, see how a couple more layers of burnished color makes a difference?

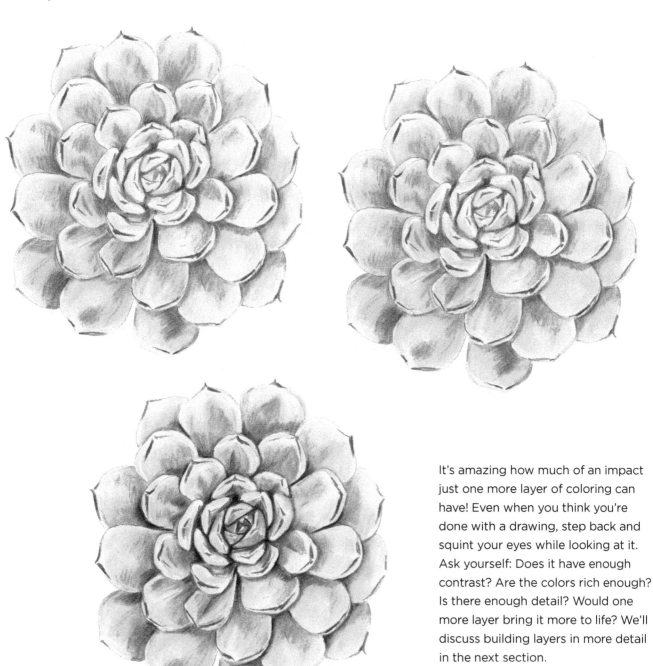

It's amazing how much of an impact just one more layer of coloring can have! Even when you think you're done with a drawing, step back and squint your eyes while looking at it. Ask yourself: Does it have enough contrast? Are the colors rich enough? Is there enough detail? Would one more layer bring it more to life? We'll discuss building layers in more detail in the next section.

You can also burnish with lighter and darker colors if you're shading an object, or to give a drawing more highlights and shadows. Instead of using the same colors as the rest of your drawing, grab a white pencil, a black pencil, or even the complementary color! A white pencil will burnish your colors and lighten them at the same time. If you use black, like in this tulip illustration, you change the shade of the color while burnishing. You can also use these last burnished layers to show texture and direction in your drawings, like the petals and leaves in these tulips.

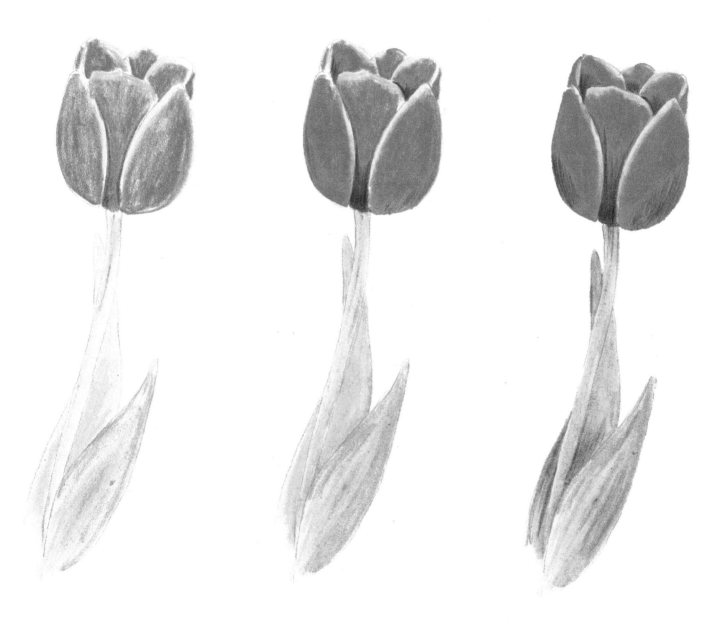

SOLVENTS

Another tool for blending colors, solvents help break down the wax binder to blend the pigments together. Some solvents are gentler and subtly break down the binder to lightly blend colors, while others completely dissolve the binder, giving you a painterly effect as you blend the colors with a cotton swab or paintbrush. Solvents can help fade any pencil strokes from your page. They can also sometimes speed the process of filling large areas with color, as you can blend loose strokes into a seamless plane of color.

There are a variety of solvent options, but some are more aggressive and toxic than others. Rubbing alcohol works for lighter areas you want to blend, but since it's gentler, you can't blend the colors as well as with a stronger solution.

Mineral spirits are more aggressive than solvents, but make sure you use odorless mineral spirits, as they can be quite potent! For an even stronger option that will break down the wax binder completely, look for distilled turpentine.

Before trying any of these solutions on your drawings, do a test on scratch paper. Use just a little at time, as you'll need to wait for your paper to dry before you can add anything on top of that area. A little can go a long way when using solvents!

LAYERING TO BUILD DIMENSION

Working with colored pencils is similar to working with other media in that you build up layers to give your piece depth, rich color, and contrast. While it can be tedious and you may feel like your piece is never going be complete, working slowly to build up the layers is crucial. Layers aren't just about building up the colors—layers can build up the texture too. Take these two pieces, for example. While the first drawing may look and feel complete, see how much of a difference a few more layers of color and texture can make?

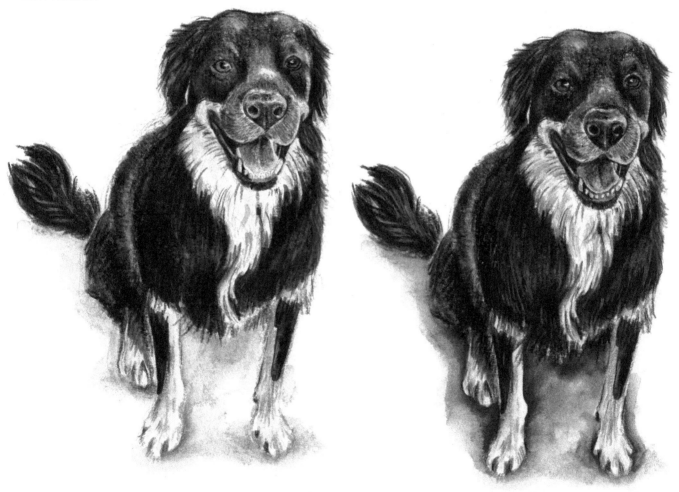

To achieve this, build up the layers from light to dark. If you're working on light paper, do your best to preserve the white space for your highlights. With colored pencil, you're essentially staining a blank slate as you go, and it's hard to work backward and erase color. While your colored pencil set may come with a white colored pencil, it will never be opaque enough to add fully white highlights, so you'll need to preserve the white space on your paper for these pristine highlights!

LAYERING EXERCISE

Choose any small object to draw. It can be a coffee cup, a piece of fruit, a book, a shoe...any inanimate object that's not too complex will do. Sketch it lightly in pencil first, breaking it down into its basic shapes and making notes as to where any highlights should be saved.

Select your colors for the piece, starting with the basics. Add your first layers lightly, holding your pencils on their sides to apply soft, smooth layers. Be sure to avoid any areas that you've marked for highlights! Once you're done with the first layer, pause to take a photo with your camera or phone, or make a quick scan on your computer.

Make another pass with your colored pencils to add a layer of color and begin burnishing the colors into your paper. After each layer of color, stop to take another photo.

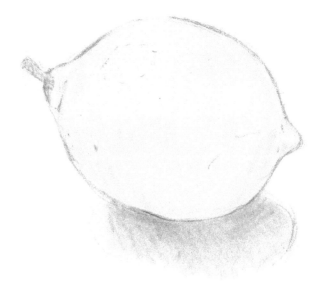

You should be burnishing the colors well into the paper now, filling in most of the tooth. Each new piece of art is different, so you may feel you reach this stage after five layers, or it may take ten layers! Take your time and slowly add more colors, keeping in mind that using complementary colors will create more realistic shading.

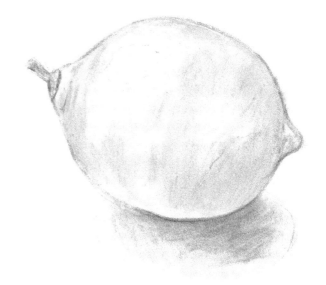

Your layers should also build texture, if the piece needs it. Your marks can help convey shape as they curve around the sides of your object.

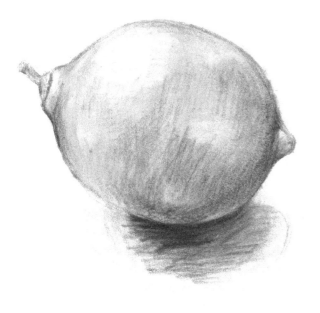

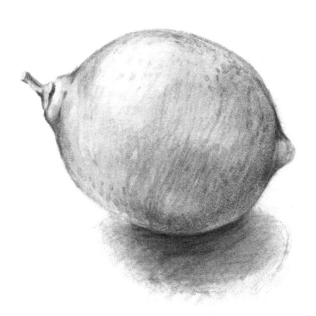

Once you feel your piece is complete, make one more pass with your darkest shades to get those shadows to "pop." Don't be afraid to add another layer with your white or lighter colors to make the highlights shine or to burnish the lighter colors a bit more.

When you're all done, scroll back through your photos to see just how far your piece came since that first layer. Compare your middle point to your final point. Do you see how much difference a few more layers and a few more colors can make? Remember this exercise whenever you feel yourself starting to lose patience with a drawing that doesn't feel finished.

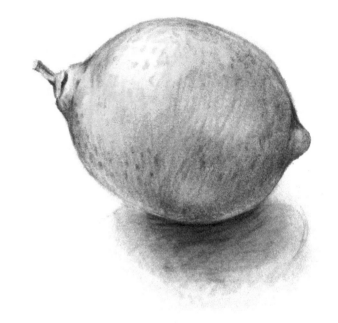

It's amazing how many colors you may use within one drawing to bring it to life! Here are all the colors used to complete this little lemon.

WORKING ON TONED PAPER

Even though colored pencils are already a colorful medium, there are ways to incorporate even more color into your drawings! One of the best ways is by working on colored, or toned, paper.

You may wonder why you would want to work on anything other than a clean, white piece of paper. Working with warm or cool toned paper enables you to add to the overall feel of your drawing before you even apply color to the paper. The changes may be subtle, but the underlying tone of the paper influences how your colors appear on the page.

Warm-toned papers bring warmth to a drawing.

The darker your paper is, the more visible your white colored pencils will be!

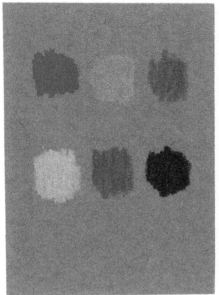
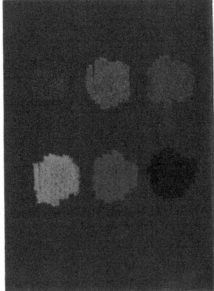
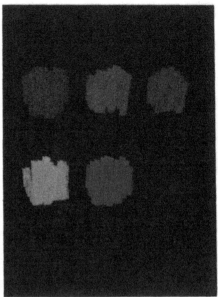

Cool-toned papers have the opposite effect, sometimes even changing the tone and shade of a color altogether.

While I love working on a clean, white piece of paper, toned paper can bring a warm or cool vibe to a drawing that I can't achieve otherwise. The color of the paper can become an additional color in your piece too. Compare these examples.

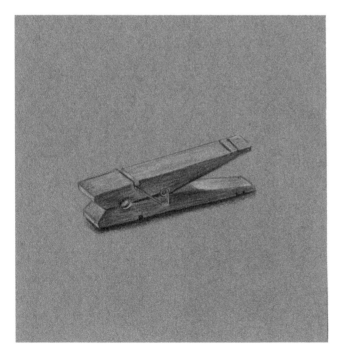
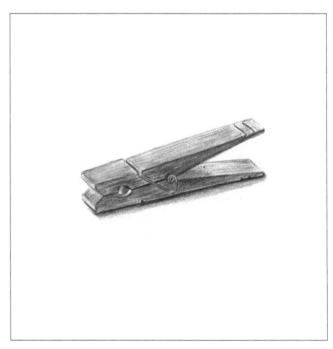

On the toned paper, I added more highlights and shadows, while the brown tone of the paper defines the color of the clothespin.

On the white paper, I added the color and shadows using the white of the paper as natural highlights on the clothespin.

When you're using a limited color palette, working on toned paper is one way to add another color to your piece without additional pencils. The tone of the paper is an additional color in your drawing.

Depending on how dark your paper is, you may have to shift the way you think about coloring your drawings too. When working on white paper, the negative space (the white of the paper) creates your natural highlights. On medium-toned paper, you have some middle shadows and values already in your drawing, so you'll add the highlights and shadows. On black paper, the darkest shadows are already there and you need to build the lighter colors and highlights on top.

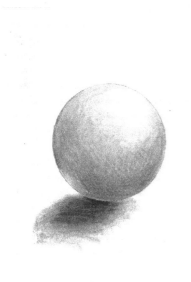
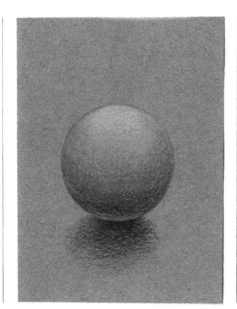
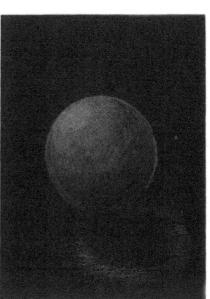

Working Monochromatically

If you want an added challenge, try working monochromatically on toned paper. Using only white, gray, and black pencils on black paper can be incredibly challenging. Instead of interpreting colors straight to the page, you're translating colors into values on paper. If you need a little help getting started, you can always convert a photo to black and white to help you get the hang of translating bright colors into shades of gray. As you grow more confident in your skills, I recommend trying to draw monochromatically from the get-go. We'll work monochromatically and on toned paper later!

SEEING & USING PATTERNS

One thing I love about working with colored pencils is that they work well with a variety of styles and methods. While oil paints and chalk pastels are ideal for certain subjects and styles, colored pencils are a very versatile tool! Not only are they perfect for realistic drawings and studies, but you can also use them for coloring in coloring books or creating your own patterns and designs.

In this next section, we'll get more playful with our colored pencils! While there are still some in-depth studies in this section, you'll also find tips to help you loosen up, look for patterns in your everyday surroundings, and translate your studies and drawings into patterns.

LOOKING FOR PATTERNS

When looking for patterns to incorporate into your drawings, a natural place to look is in nature! Patterns occur naturally within succulents, flower petals and centers, and even leaves. These not only make ideal subjects for drawing studies, but also inspiration for patterns.

Dahlias, in particular, offer a unique challenge for a realistic drawing because of their tightly packed rings of radiating petals. Their intricate petal patterns can be translated into your pattern drawings and doodles too, but first we'll do a little in-depth study. Dahlia petals, especially the larger varieties, have a similar pattern and shape to succulents, which can also be used for studies like this.

Start with a pencil and lightly draw concentric circles. These will help guide your petal sketching so they radiate from the center evenly.

DAHLIA COLOR SWATCHES

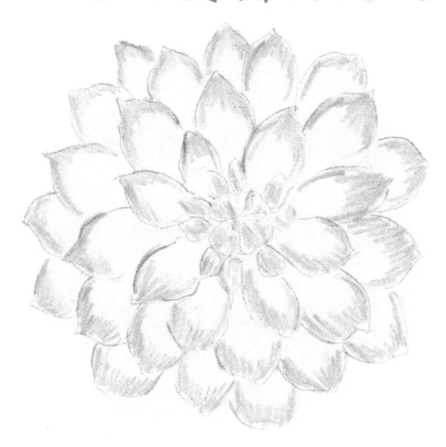

With your lightest yellow and coral pencils, start shading in the petals. This dahlia doesn't have any bright white highlights, so you don't need to worry about preserving any white space. Shade in slowly with the side of the lead.

With a slightly richer yellow, build up the color in your petals. You can start burnishing this yellow into the coral to blend it into the rest of each petal.

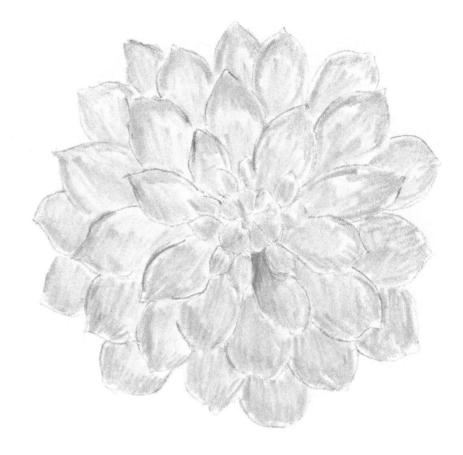

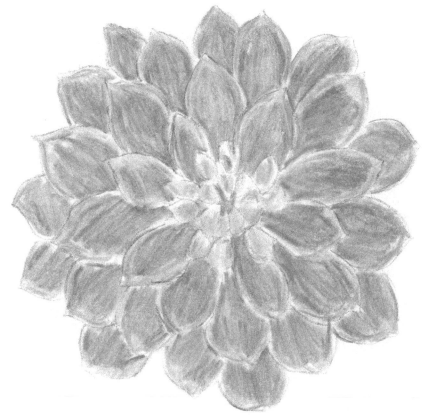

Time to get those rich tones! Using darker yellow and orange, shade in the petals with long, smooth strokes. These strokes will help add texture to the petals and show their direction as they radiate from the center. Be careful not to color in any of the lighter yellow areas that will form the lighter highlights. Concentrate your color along the bottom of each petal and where they cast shadows on the underlying petals.

With red and fuchsia pencils, burnish in some darker shadows along the bottoms of the petals and along their ridges.

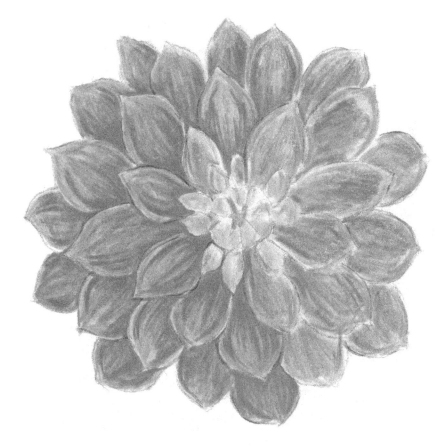

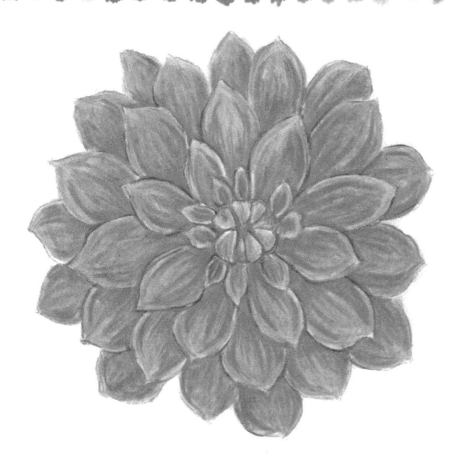

Continue with the red and fuchsia colors until you've shaded in all the shadowy areas and each petal has some darker ridges.

Using a well-sharpened dark brown pencil, add another layer to the darkest shadows of the flower. Look along the bottom corners of the petals closest to the center for areas to darken to give your flower more contrast and make it "pop" off the page! If needed, grab one of your lighter yellows or a white pencil to burnish the lighter areas of the petals.

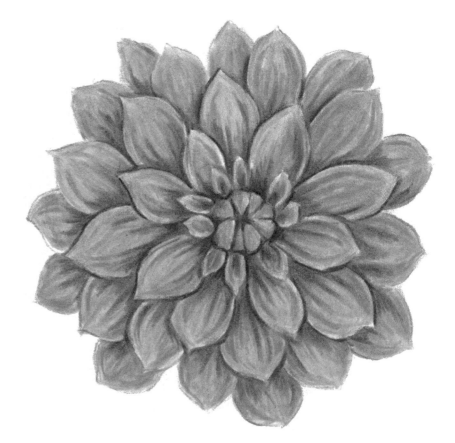

PLAYFUL PATTERNS

After you've completed a full study of the dahlia, it's time to get playful! At its simplest, a dahlia is a circle! Start with a small circle on your page.

Draw some rounded triangles pointing in toward the center of your circle. These rounded triangles, or teardrop shapes, will be the petals. Let the petals overlap and curl over one another.

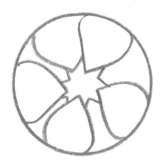

Now it's time to add the petals around the center! Using the same rounded triangle shape, draw a layer of petals around the outside of the center circle. Make them roughly the same size as the first petals.

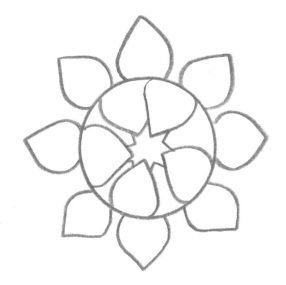

In between each of these first petals, draw another slightly larger one. Dahlia petals radiate out in repeating rings, growing larger and larger with every ring.

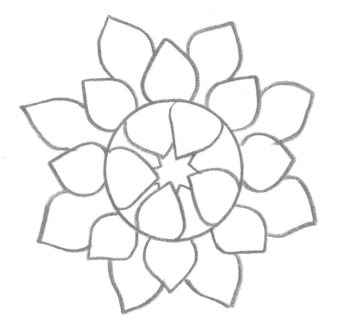

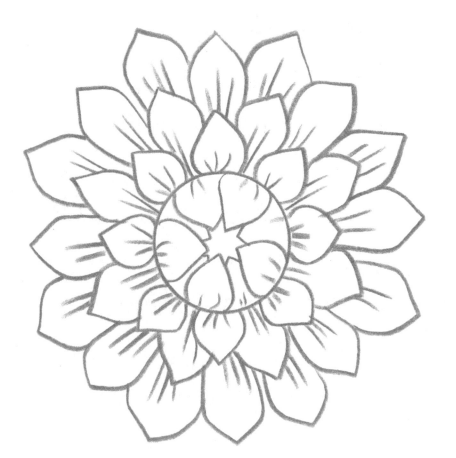

Continue to add as many layers of petals as you want. You could even add them until you go off the edges of the page. Add little definition lines to each petal, which help them appear to radiate from the center.

You can also draw these patterns in clusters, like a garden of dahlias all blooming together. These dahlia doodles are similar to mandala patterns, which are also comprised of concentric, radiating circular patterns.

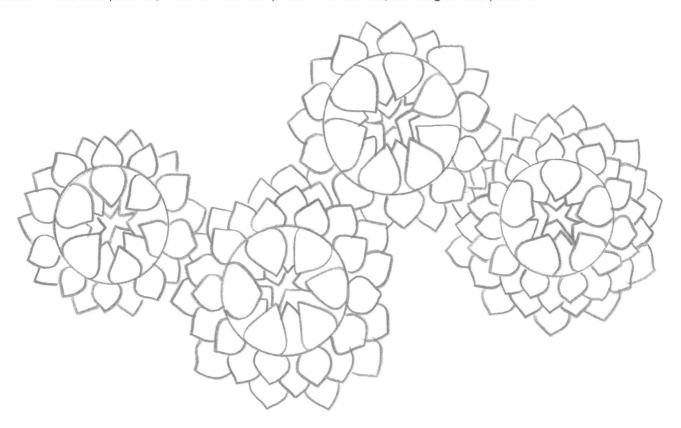

The shape of the petals can also be used in other ways. How about using these same shapes along linear patterns to create long patterns and borders?

Another way you can incorporate circular patterns into your colored pencil creations is by making your own coloring pages. Repeat the dahlia doodle exercise with regular pencil and go over it in pen. When the ink is dry, erase any rogue pencil marks. You'll then have an original coloring-page design to color in! Want to share the fun? Make photocopies of your drawings to share the coloring fun with your friends!

COMPLEX PATTERNS

Petals aren't the only way to incorporate nature into your pattern making. The entire flower can be inspiration for creating patterns in different styles. You can create complex patterns that focus on the intricacy of the petals or simplify the whole flower down to its basic shapes and colors to create more modern patterns.

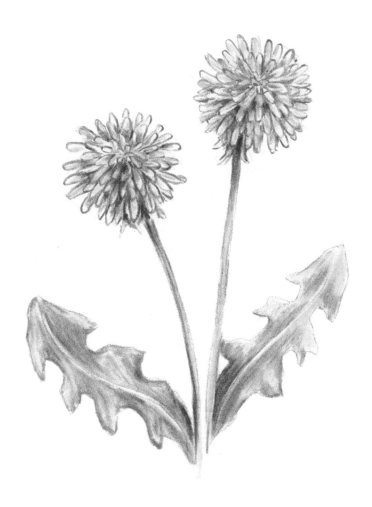

After completing this dandelion study, I decided to break it down into basic shapes and isolate the colors into a more graphic pattern, shown on the following page. Using the colors in bold chunks for the flower rings, petals, leaves, and stems gives the pattern a more retro feel.

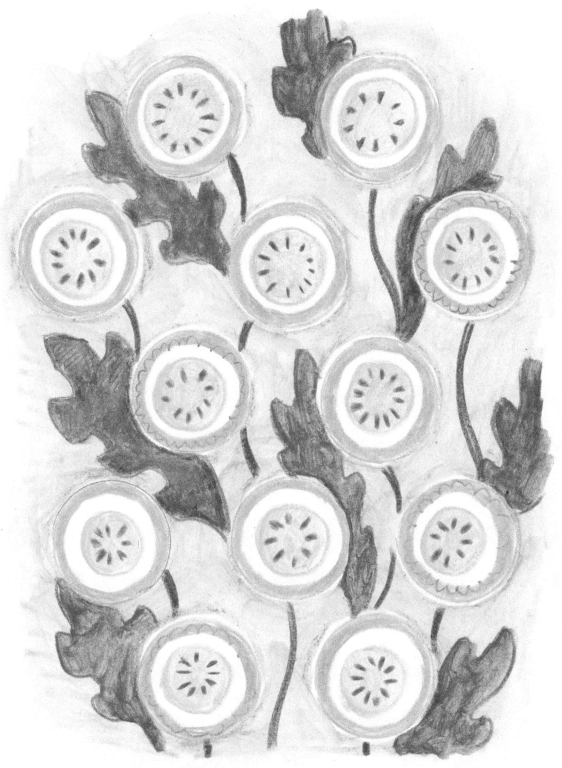

In this drawing, I also incorporated watercolor pencils to fill the background areas. Watercolor pencils are perfect for instances like this where you need a lot of color, without the texture of pencil strokes.

USING NEGATIVE SPACE

Another way to create patterns is by focusing on the negative space in your drawings. Negative space is the area around and between subjects in your drawings. Sometimes the negative space is filled with color, but sometimes it's the absence of any color left by an outside shape.

When working with negative space, it can be helpful to work with simple, easily identifiable shapes. I decided to use the iconic shape of the ginkgo leaf for this exercise, but you could use acorns, petals, monstera leaves, or any other easy-to-identify natural shape.

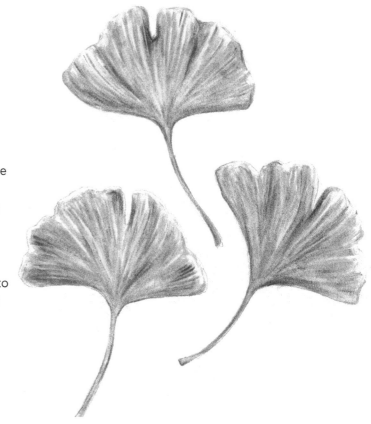

EXERCISE

1. Draw a large circle in regular pencil. Inside the circle, start drawing the natural shape—in this case, ginkgo leaves—all over. These light sketches can overlap one another and even go over the edges of the circle.

2. Once you're happy with the placement of your shapes, grab some colored pencils. Start shading around the patterns to reveal the negative space of your shapes! I used yellow, orange, and red crosshatch marks to shade in my circle, but you could also shade the circle with smooth, even strokes, or use watercolor pencils to create a more painterly negative-space pattern.

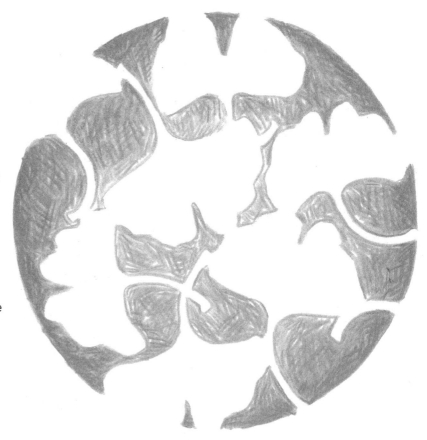

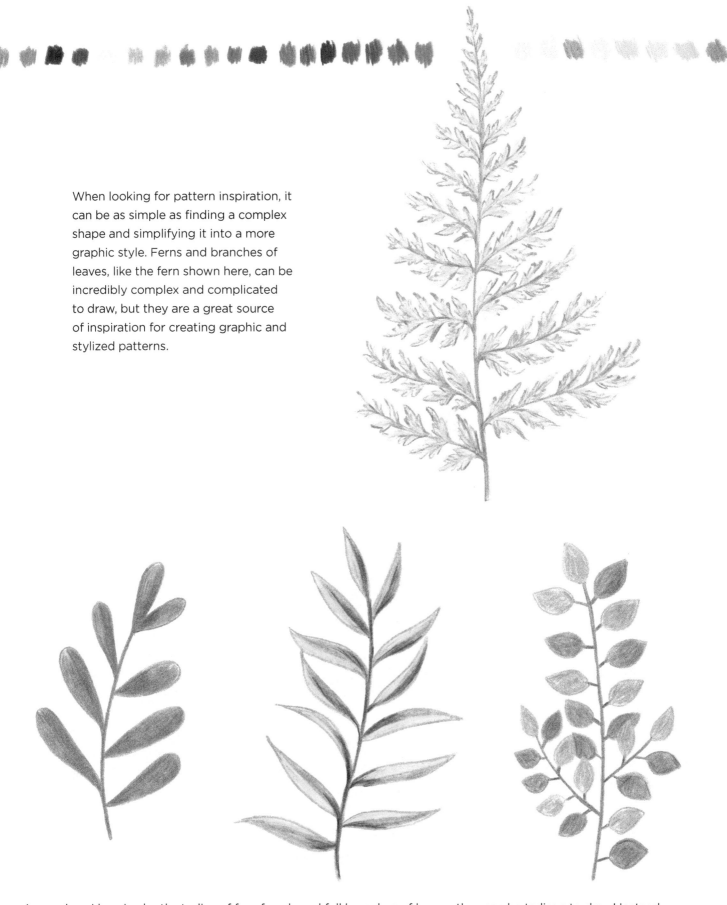

When looking for pattern inspiration, it can be as simple as finding a complex shape and simplifying it into a more graphic style. Ferns and branches of leaves, like the fern shown here, can be incredibly complex and complicated to draw, but they are a great source of inspiration for creating graphic and stylized patterns.

As much as I love in-depth studies of fern fronds and full branches of leaves, they can be tedious to draw! Instead, you can break these down into simpler, easily repeatable shapes that gradually grow along a skinny center stem. These leaf studies may not be realistic, but they're fun to draw! They can also be incorporated into other projects: frames around lettering, banners, or even repeat patterns for fabric. The options are endless!

"DRAWING EVERYDAY LIFE"

When trying to decide what to draw next, sometimes the best solution is to look to your surroundings for inspiration. Whether you're in your kitchen, hanging out in your living room, on your lunch break at work, or relaxing at the local coffee shop, drawing items from your everyday life is a great way not only to study your surroundings, but also to build your drawing vocabulary and bring a new appreciation to the unexpected inspirations around you.

Everyday life drawings can be as simple as your favorite coffee mug or the bowl of fruit on the counter, or as complex as your bulletin board or a collection of travel souvenirs. There's so much inspiration to be found around you—even your herb garden can be a drawing subject!

FRUITS & VEGGIES

The food you eat can be a great starting point for drawing in colored pencil. Fruits and vegetables are colorful subjects featuring unique shapes, sizes, and textures to explore.

APPLE

Apples are fun to draw—there are so many colors on this one small fruit! It may look solid red at first glance, but a closer look reveals the different shades and highlight colors waiting to be captured in colored pencil!

Lightly sketch the apple in pencil, paying attention to the irregularities in its shape. Don't forget the divot at the top where the stem sprouts. I like to add light marks to indicate the highlights too.

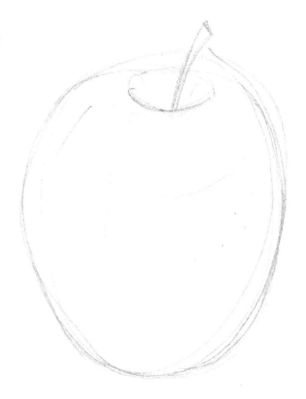

APPLE COLOR SWATCHES

Using the sides of your colored pencils, add long, smooth strokes of color that curve with the shape of the apple. The curved lines will help give the apple dimension and make it appear more realistic. Start with your lightest undertones or highlight colors.

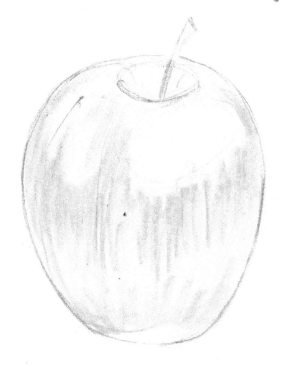

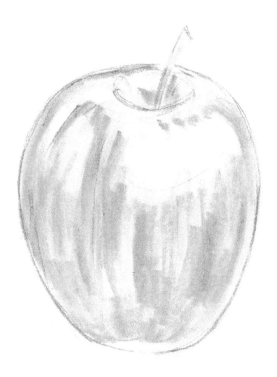

Build up that first layer with colors that are slightly richer and darker than the first, paying careful attention so you don't color in the white highlight areas. We'll darken these areas a little toward the end, but for now, do your best to preserve the white space.

Time to start building up those rich, red tones. Using the side of your red pencil, add a layer of red. It doesn't need to be a solid layer of color—keeping the color application chunky and striated looks more realistic and allows your first layers of color to peek through. Add a light layer of color across the highlight areas that aren't pure, shiny white.

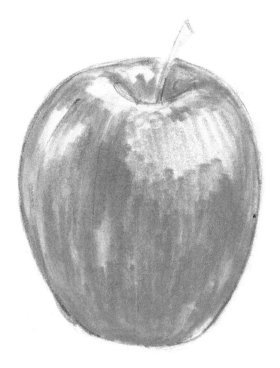

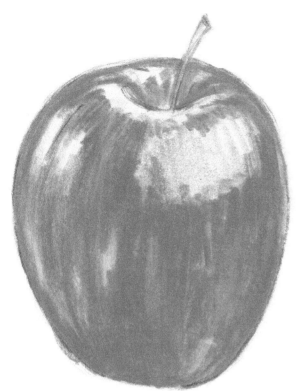

Using the same red or a darker shade, start burnishing the layers and building up more color in the areas with more shadow.

Finally, using dark browns and greens, make those darker shadows and stripes of color more prominent. Make sure all your marks curve along the apple to help show the overall shape.

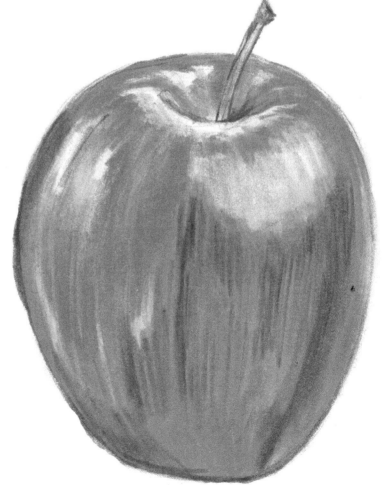

AVOCADO

Another piece of produce that's fun to draw is an avocado! The creamy interior offers a good exercise for blending colors smoothly, while the exterior is bumpy and textured, creating an interesting contrast and combination of exercises.

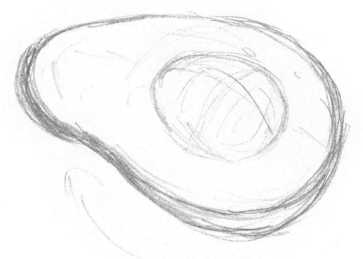

Grab an avocado and slice it in half. I opt for the side with the pit, but you could also draw it without the pit. Loosely sketch the avocado half. I like to draw curved lines for guidance on the curves when I start adding color. I also add a quick note of where the avocado casts a shadow on the table.

Clean up some of your pencil marks before adding the first layers of light greens and browns for the green flesh, outer skin, and pit.

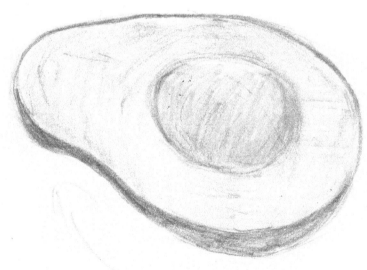

AVOCADO COLOR SWATCHES

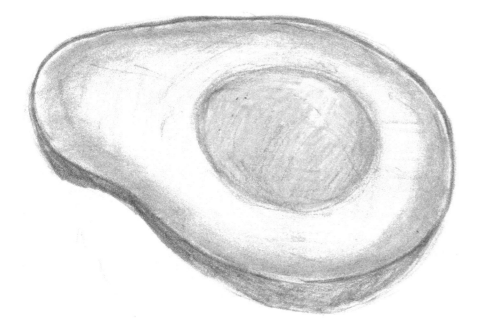

Using the sides of slightly darker green and yellow colored pencils, start blending in smooth layers of color on the avocado flesh. You can also use some yellow on the pit. Try to keep the layers as smooth as possible on the avocado flesh; your layers can be chunky and loose on the pit and outer skin, since these areas have more texture and variation.

Add more dark green along the outer rim of the green avocado flesh. With light green, burnish those colors to create a smooth transition from light to dark. Using a darker brown, make chunky strokes on the outer skin to build up the texture.

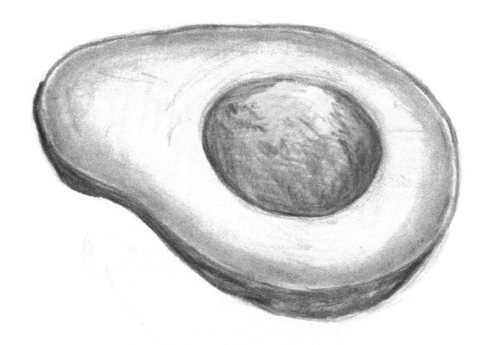

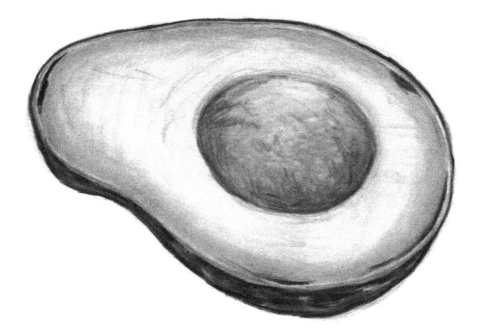

With a black or very dark brown pencil, make that outer skin "pop." Using the same chunky marks as before, add more texture and shadow to the outer skin of the avocado. Pay attention to any shadows on the pit that need to be darkened, as well as small gaps between the skin and the avocado flesh. Another layer of dark green on the outer rim of the avocado flesh helps brighten the inner area.

With one of your lighter brown pencils, shade in the pit with more texture. Use that same brown to show any discolorations or variations on the flesh of the avocado too. With a medium gray, add the shadow beneath the avocado.

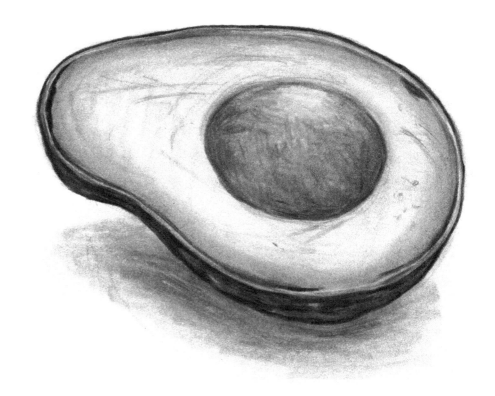

BERRIES

Even the smallest fruits can be challenging to draw. Strawberries and blackberries are rich in color and detail, so they can be more tedious subjects, but it's so satisfying when you draw one realistically. Plus, they're a great snack when you're done drawing!

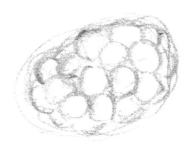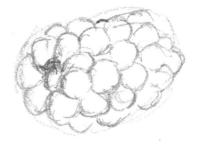

I like to draw a few blackberries at a time, but you can focus on just one if you prefer. Lightly sketch the overall shape before diving in and sketching the individual drupelets (the small juicy balls on the fruit).

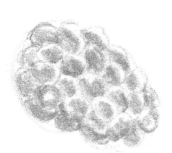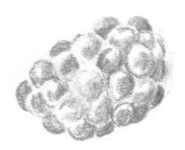

While blackberries look nearly entirely black once fully colored, you want to build that color up slowly. Start with warm fuchsia and light pink to shade in the drupelets, taking care to avoid the highlights. Add a small spot of yellow for the top bit where the stem would attach.

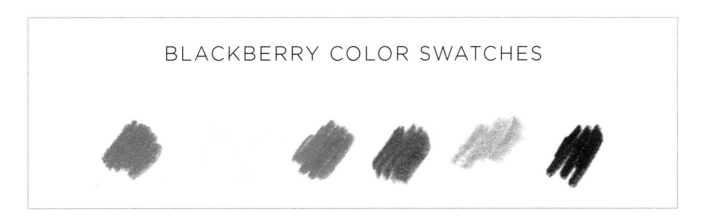

BLACKBERRY COLOR SWATCHES

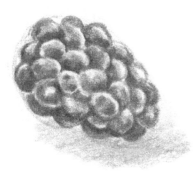 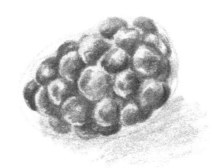 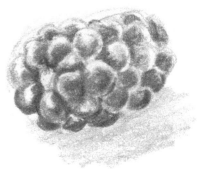

With a dark purple pencil, start building up the shadows. Pay attention to the bumpy surface on the drupelets and how they catch the light in different ways. Not all drupelets are perfectly round, so aim for more faceted shapes. Add light gray below the berries for the shadows.

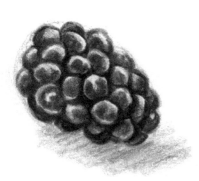 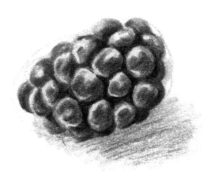 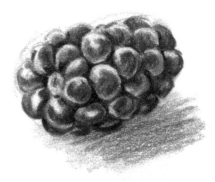

Alternate between dark purple and black to darken the shadowed areas on the berries. I use dark purple to lightly shade over the highlights on some of the drupelets that catch less light and aren't bright white. With a finely sharpened black pencil, shade the tiny shadows between the drupelets.

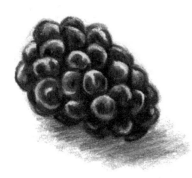 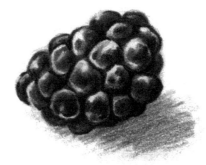 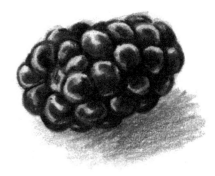

Clean up any stray pencil marks and give those drupelets one last punch of black. You can also burnish them with your fuchsia or purple pencil to blend them more smoothly. This will make the blackberries "pop" off the page! Darken the shadows underneath the blackberries too.

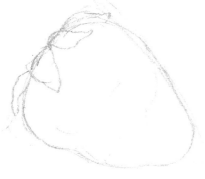

All those little strawberry seeds take time, but the results look lovely. Start by breaking down the strawberry into its basic shapes. I've found that most strawberries are roughly triangles with very rounded tops. From there, adjust your sketch to create the curved point, and add some marks to indicate the leaves.

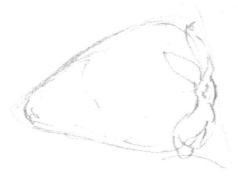

With a yellow pencil, start shading the lighter areas of the strawberries for the base layer of color. You can also add some yellow on the leaves. Start building up red layers in areas of richer red, both in the shadows and in places with a deeper concentration of color.

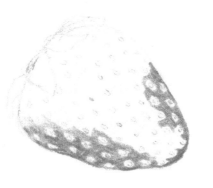

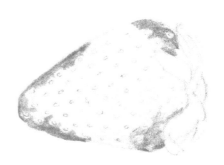

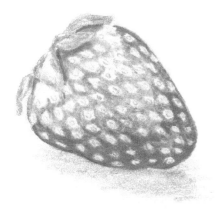

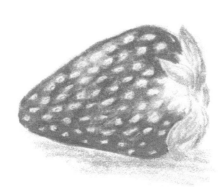

Using red or a shade of fuchsia, start filling in the rest of the strawberries. Leave a slight halo around each of the seeds; you want to retain this space for a highlight or shadow. Add some light green to the leaves and a layer of gray for the shadows beneath the strawberries.

STRAWBERRY COLOR SWATCHES

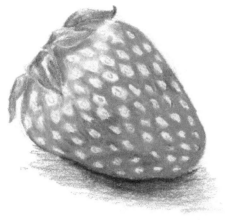

With a warm brown pencil, start building up the shadows underneath the strawberries. You can also start building up the shadows in the leaves with a medium shade of green.

With a finely sharpened golden yellow or yellow ochre pencil, shade in all the seeds. Using dark brown and black, shade in the shadows cast by the leaves, both on the other leaves and on the strawberries themselves. You can also sharpen your pencils and shade around the deeper seeds on the strawberries.

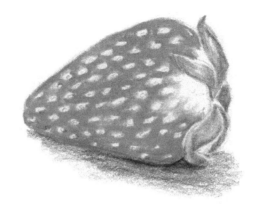

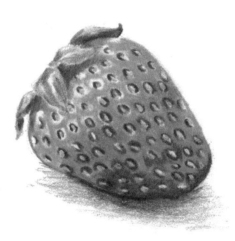

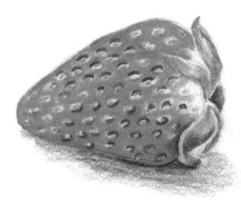

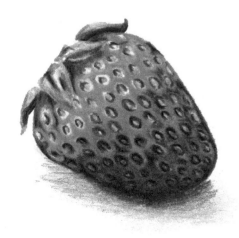

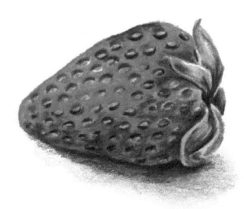

With your black pencil, continue to shade the strawberries and leaves, as well as the cast shadows. Using white, burnish around the seeds to add more highlights. You can continue to burnish with red and fuchsia for the middle tones until you're happy with the look.

GLASS OBJECTS

Looking for drawing subjects in your home often brings the challenge of drawing shiny or transparent surfaces. Drawing glass takes practice and patience. The keys to making glass look realistic are smooth blending and careful preservation of highlights!

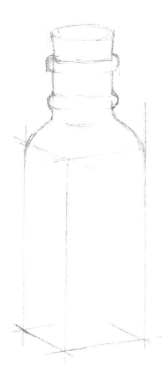

Start by lightly sketching the outline of your subject, paying close attention to the angles of the sides and the lids or tops. Square or rectangular bottles have some perspective skews, so take your time to carefully sketch the sides, making sure they're going in the right direction. Round jars don't have this challenge, but make sure you have the correct angle for the lid, especially if you're looking at it from a sharp angle, in which case your circular jar will have an oval-shaped top.

Clean up your pencil sketch and finalize your lines. Draw more detail and take note of the bright white highlights. I like to outline the bright highlights so I don't get carried away and accidentally color them in. These highlights will curve and follow the angles of your bottles and jars, helping show their shape.

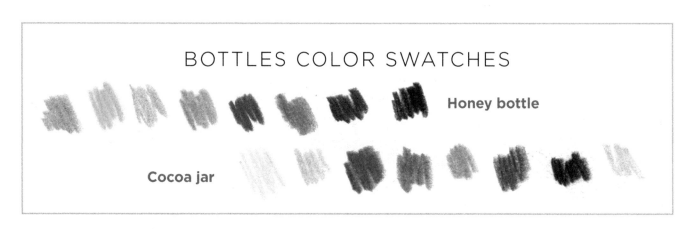

BOTTLES COLOR SWATCHES

Honey bottle

Cocoa jar

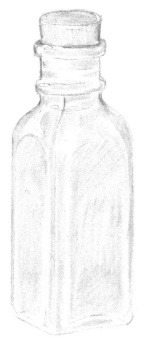

For the first layers of color, use the lightest colors on your object. For the honey bottle on the left, I use light brown and light golden yellow for the base layer and apply it very softly. On my cocoa jar on the right, I use golden yellow on the lid and a soft, warm brown for the jar. Make sure you preserve the highlights! You can always go back in and make a highlight smaller, but it's difficult to erase color entirely if you add too much too soon.

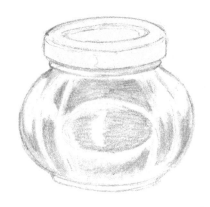

Time to start building those middle layers! I alternate using my first colors and a shade slightly darker of each, layering them slowly to create smooth layers and color transitions. I also add gray to the gold lid of the cocoa jar to start developing the brassy-toned shadows.

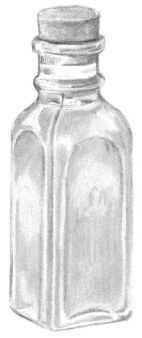

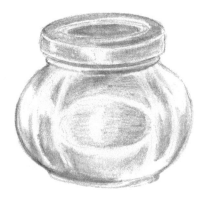

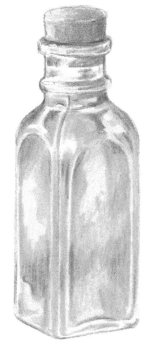

With the middle layers developed, it's time to build the shadows. The shadows on the honey jar are all warm-toned, so I use a very warm brown at first, gradually blending it into the yellows and still avoiding the bright highlights. The cocoa jar has sharper, darker shadows, so I use darker browns, grays, and even some black.

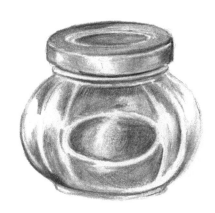

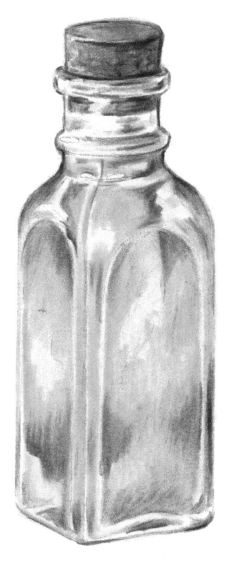

For the final shadows, I use dark browns and blacks in small select areas. Too much black can weigh down a drawing and reduce the luminosity of the glass. Add a little bit at a time and pause to see if it needs any more to avoid adding too much dark shadow at once. A touch of blue on thicker glass makes it look shinier.

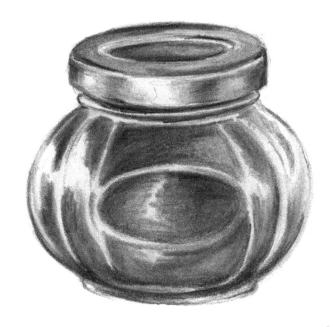

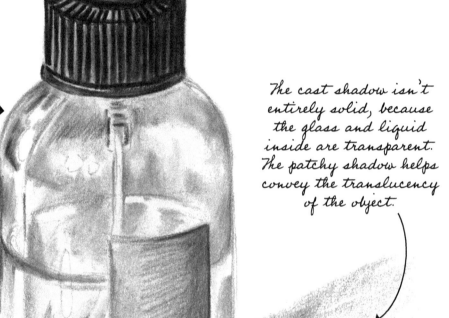

This little spray bottle poses a different challenge, because the liquid inside is clear! Drawing glass subjects may present the challenge of interpreting a clear substance inside, or an object behind the clear glass, like fruit in a glass bowl. Remember that the keys are to take your time, work slowly, and preserve the highlights and luminosity of your object.

Crisp, dark shadows next to bright highlights not only add contrast, but also help your drawing "pop" off the page.

The cast shadow isn't entirely solid, because the glass and liquid inside are transparent. The patchy shadow helps convey the translucency of the object.

SPRAY BOTTLE COLOR SWATCHES

DESK SUPPLIES

Your office and desk contents can also be a surprisingly good source of drawing inspiration. Small objects like tape rolls, clips, scissors, and bulletin boards are all great options! Try grouping a few objects, instead of drawing something, like a single clip, floating on a page by itself.

Gather your items and lightly sketch them in pencil, breaking them down into their basic shapes before adding more details and erasing extra guide marks. I also make light notes of the shadows cast by the objects.

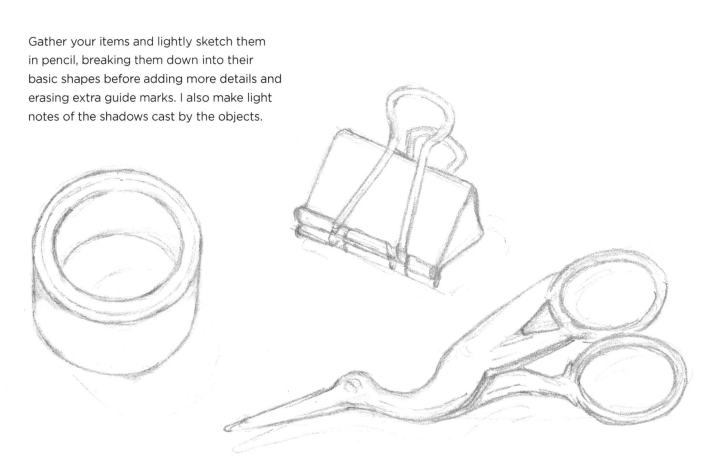

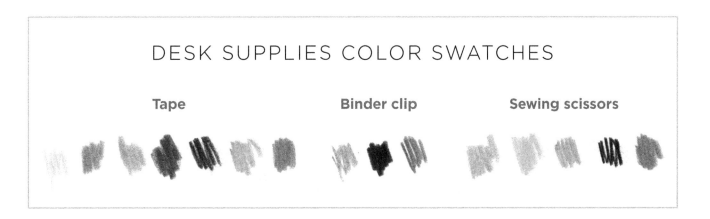

DESK SUPPLIES COLOR SWATCHES

Tape **Binder clip** **Sewing scissors**

Lightly sketch in the base layers, using the lightest color you can find on each object.

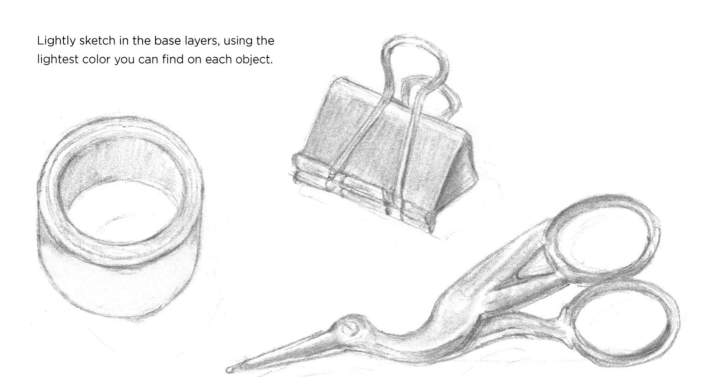

With dark gray, start shading in the middle shadows on the objects; then grab darker shades of each of the first colors and blend those in too.

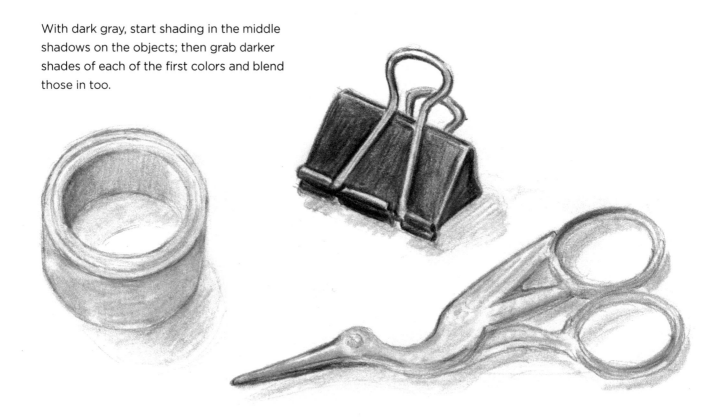

Start burnishing darker shadows and layers. At this point, you can also start building up the details and the shadows cast by the objects.

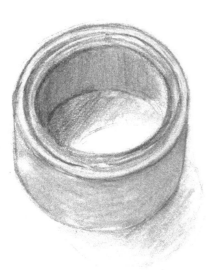

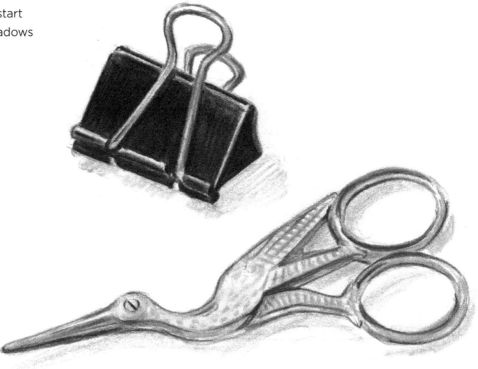

Finally, use dark grays and black, if needed, to get those shadows and details to "pop." Make sure your pencils are finely sharpened for the tiny shadows that curve along the edges of your objects. Adding those small, fine-lined shadows right next to the highlights makes them appear more crisp and realistic.

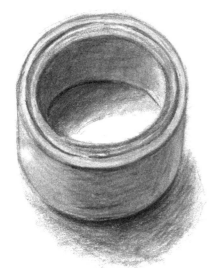

PLANTS

I have a lot of potted plants in my home—I can't get enough of them and have quite the collection to use for colored pencil studies. Their varied leaf shapes, colors, sizes, and pots are all a great source of inspiration. Potted plants vary in difficulty, so start with simpler or smaller plants and work your way up to more complex plants or arrangements. Don't stress about getting every leaf perfect. One of the perks of drawing plants is that they're organic subjects, so your drawings can be fluid and loose, reflecting the organic nature and shapes of the plant.

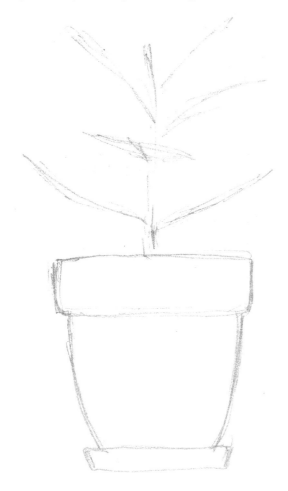

As with any subject, start by drawing lightly in regular pencil, paying close attention to the basic shapes that form larger, more complex shapes. Your first pencil marks can even be quick gesture lines to show angles of the leaves. I loosely sketch the center veins of the leaves in this variegated rubber plant to get the angle and placement correct before trying to outline each leaf.

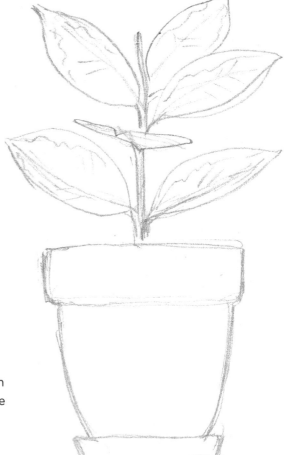

Outline the leaves and note any color changes or patterns you see in them. Variegated rubber plants have fun pink and cream edges on the leaves, so I loosely sketch those in.

RUBBER PLANT COLOR SWATCHES

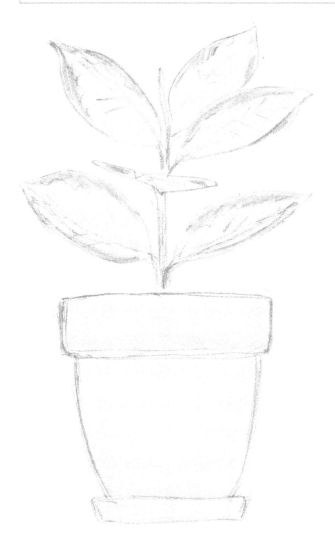

Lightly apply your first layers of color. When selecting your first color, look for the lightest color, or what could be considered the highlight color, for each portion of your drawing. This plant and pot don't have any bright white highlights to preserve, so I use the sides of my pencils to lightly shade in my first layers.

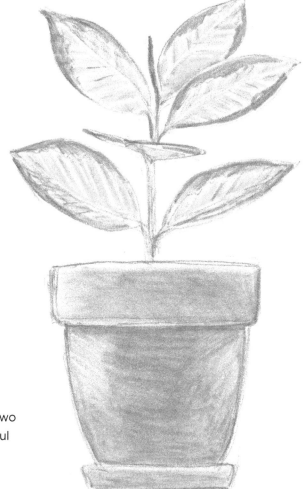

Begin building up the middle tones in your drawing. Look for colors that are a shade or two darker than your first layer of colors. Be careful to preserve any lighter "highlights" that you need from that first layer.

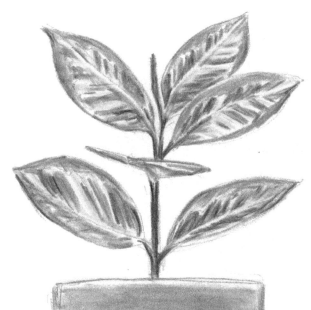

Start building up the shadows in the leaves and stems, as well as on the pot. Using the sides of your pencils will help keep the colors smooth on the pot, while the points of your pencils are ideal for adding texture and chunky color striations to the leaves.

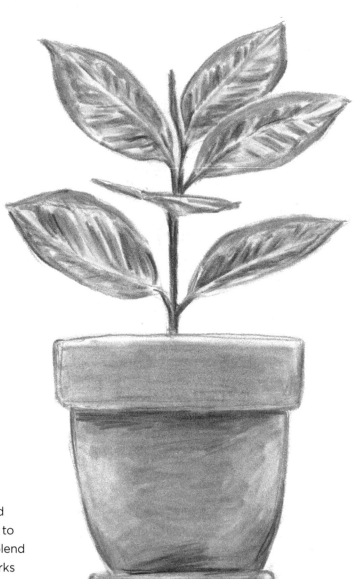

Grab your darkest shadow colors and make those shadow "pop." I also like to burnish with my highlight colors to blend the layers before adding any last marks on top for texture on the leaves.

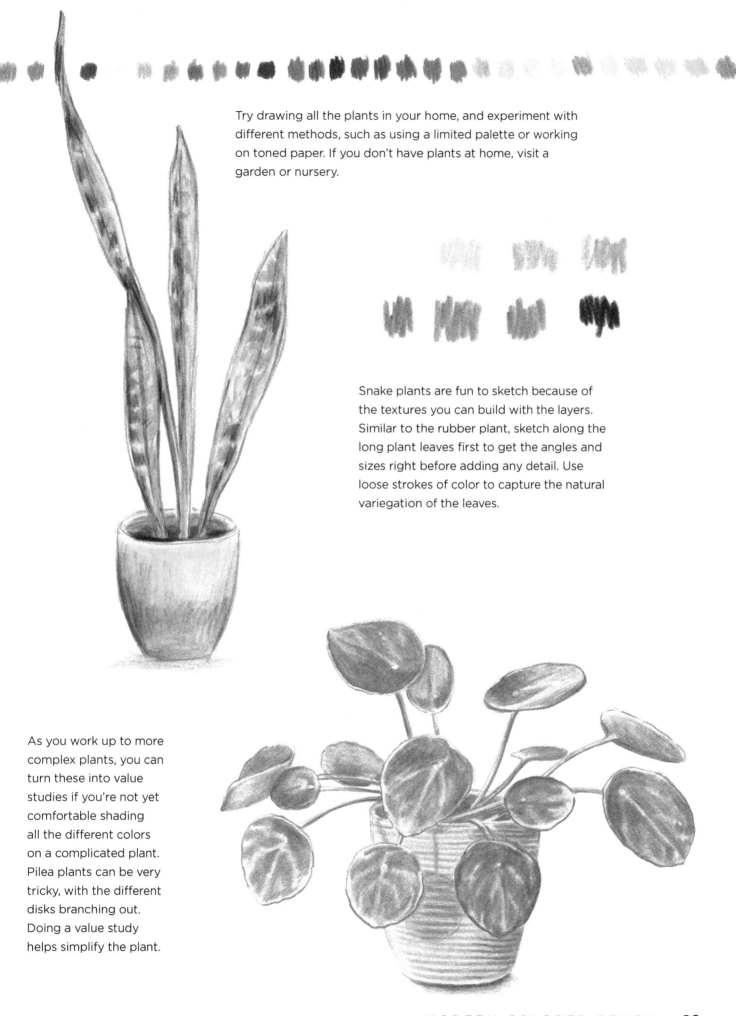

Try drawing all the plants in your home, and experiment with different methods, such as using a limited palette or working on toned paper. If you don't have plants at home, visit a garden or nursery.

Snake plants are fun to sketch because of the textures you can build with the layers. Similar to the rubber plant, sketch along the long plant leaves first to get the angles and sizes right before adding any detail. Use loose strokes of color to capture the natural variegation of the leaves.

As you work up to more complex plants, you can turn these into value studies if you're not yet comfortable shading all the different colors on a complicated plant. Pilea plants can be very tricky, with the different disks branching out. Doing a value study helps simplify the plant.

INTERIOR SCENE

Looking for small scenes around your home or focusing on single pieces of furniture can be great practice—and it's a good option if your time is limited or the weather is poor. While more complicated scenes and arrangements of furniture can be intimidating, one way to simplify and make it more approachable is to limit your color palette. Working in only a few colors—or even just one—creates a value study of lights and darks, which can be easier than trying to color match and shade complex objects.

As always, break everything down into shapes and loosely sketch your scene. It can be helpful to compare the objects and observe where they overlap one another. For instance, the tallest leaf on the fiddle leaf fig plant is about as tall as the dresser.

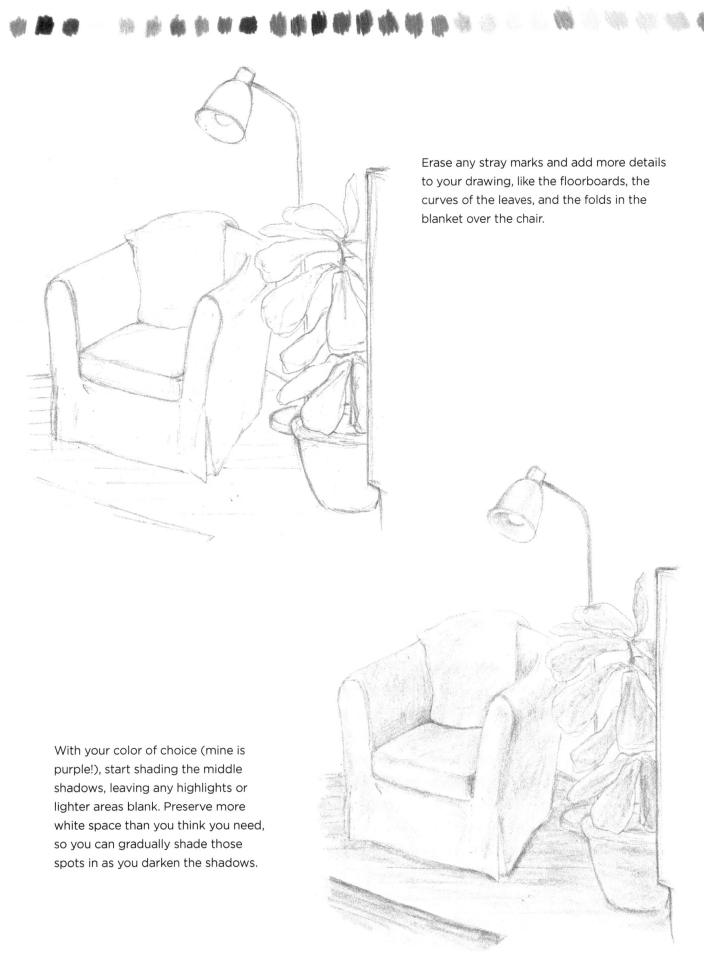

Erase any stray marks and add more details to your drawing, like the floorboards, the curves of the leaves, and the folds in the blanket over the chair.

With your color of choice (mine is purple!), start shading the middle shadows, leaving any highlights or lighter areas blank. Preserve more white space than you think you need, so you can gradually shade those spots in as you darken the shadows.

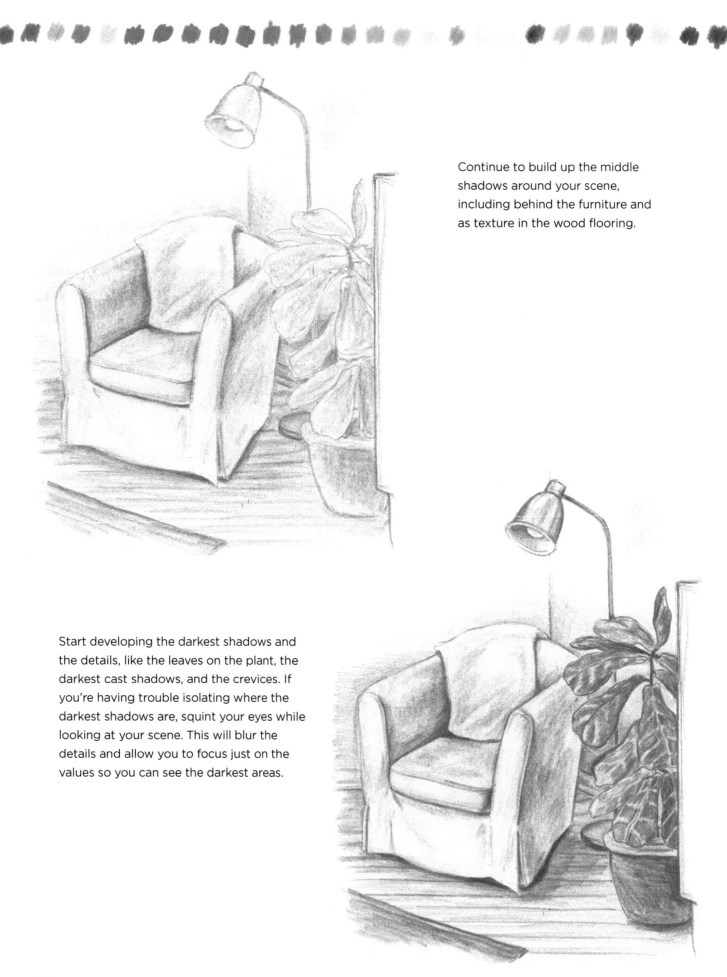

Continue to build up the middle shadows around your scene, including behind the furniture and as texture in the wood flooring.

Start developing the darkest shadows and the details, like the leaves on the plant, the darkest cast shadows, and the crevices. If you're having trouble isolating where the darkest shadows are, squint your eyes while looking at your scene. This will blur the details and allow you to focus just on the values so you can see the darkest areas.

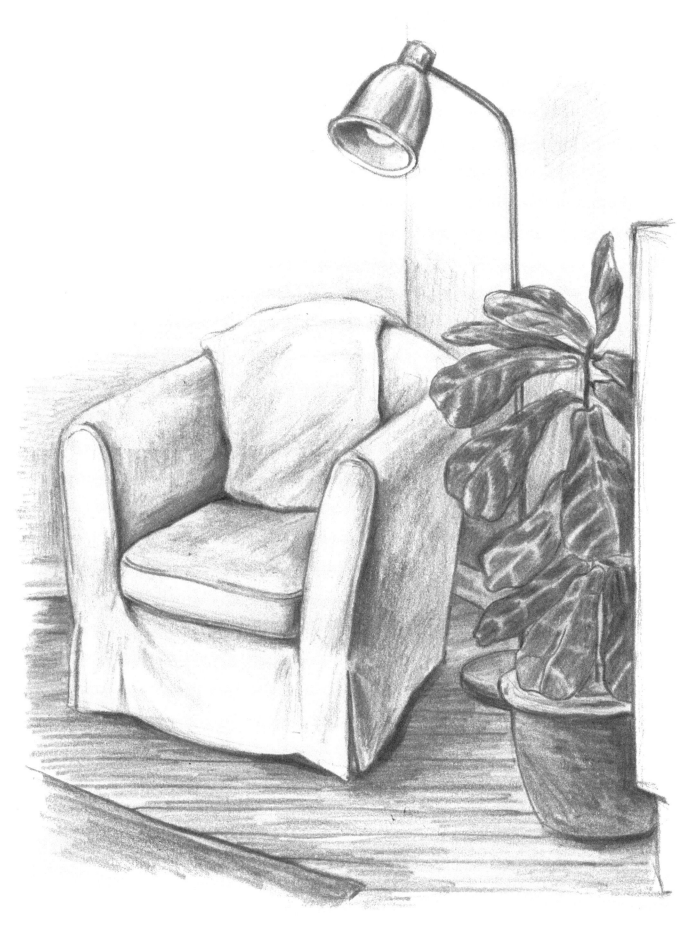

Sharpen your pencil to add fine details and the darkest shadows. Gently outline any objects that need to be differentiated from the background or objects behind them. For instance, the left chair arm is similar in value to the wall behind it; a little line along the arm helps differentiate the two.

"DRAWING ARCHITECTURE & LANDSCAPES

When traveling, drawing buildings is one of my favorite ways to fill my sketchbook. Architecture can be so different across the world, or even from one building to the next in your own neighborhood or city! In this section, we will focus on architectural details and beautiful landscapes, and how to capture them using colored pencils.

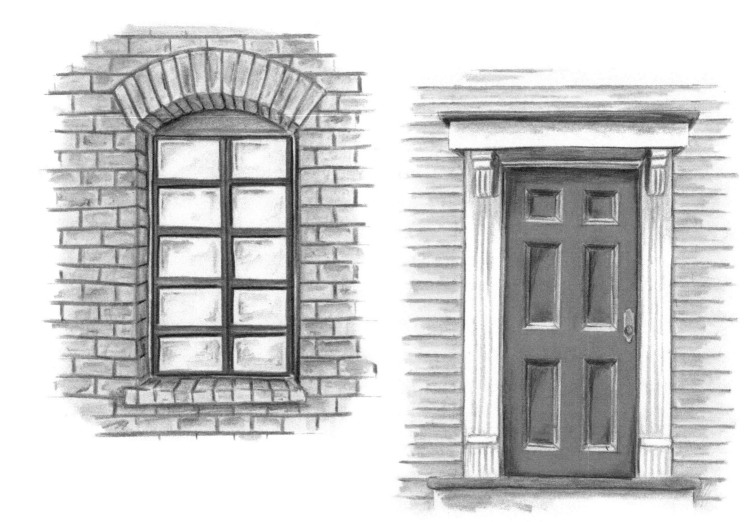

WINDOWS

Windows are a unique feature of most buildings. I have so many photos and sketches of windows from my travels across Europe. They make for great drawing studies, especially since they're often composed of very basic shapes.

For this exercise, I'm using watercolor pencils to capture a window I spotted in Italy. Watercolor pencils are a great tool for coloring an area that has no texture, or if you want to build up colors and layers more quickly. All you need to do is wait for the layers to dry before adding more color or texture to your drawing.

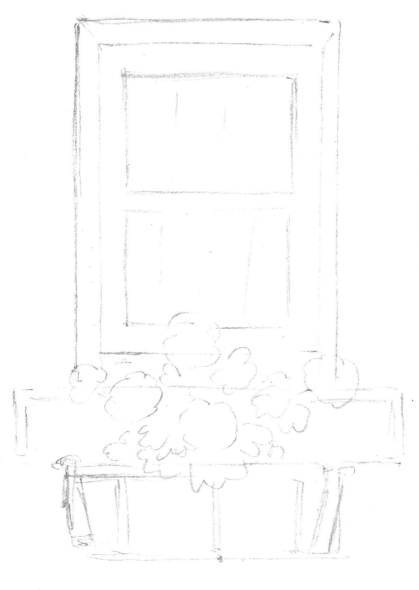

Begin by sketching the window and breaking it down into basic shapes. Even the flowers can be simplified into basic outlines, because we'll add in detail after we've applied the base and middle layers of color.

WINDOW COLOR SWATCHES

Roughly add your colors to the page. With watercolor pencils, these strokes will be blended with water, so you don't need these first layers to be smooth and seamless. With regular colored pencils, many of these colors wouldn't be added until subsequent layers, but with watercolor pencils, you can add and blend the first and middle layers all at once!

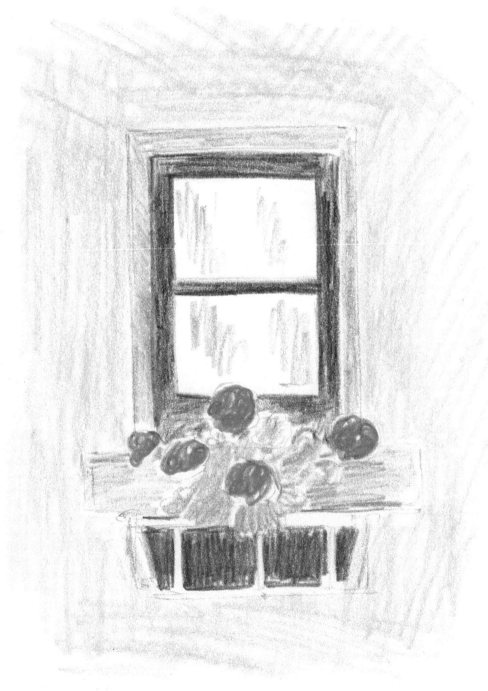

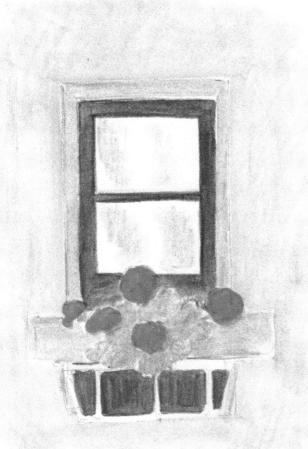

With a brush and clean water, blend each section of watercolor pencil. Be sure to rinse your brush between each color, especially when going from a dark or bright color to a lighter area. It's not fun to get red geranium color on your fresh tan plaster wall!

Allow the paper to dry fully. (Gently pat it to check, or hold it up to the light to see any reflections in damp areas.) Then add your next layers of color. Using sharpened gray and brown pencils, outline the window frame and the corners of the window recess. Use greens and orange-reds to build up the texture in the geraniums. A touch of light blue on the glass helps the window look reflective.

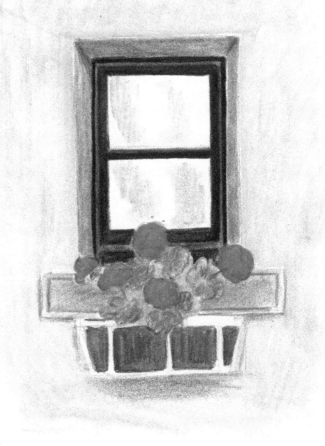

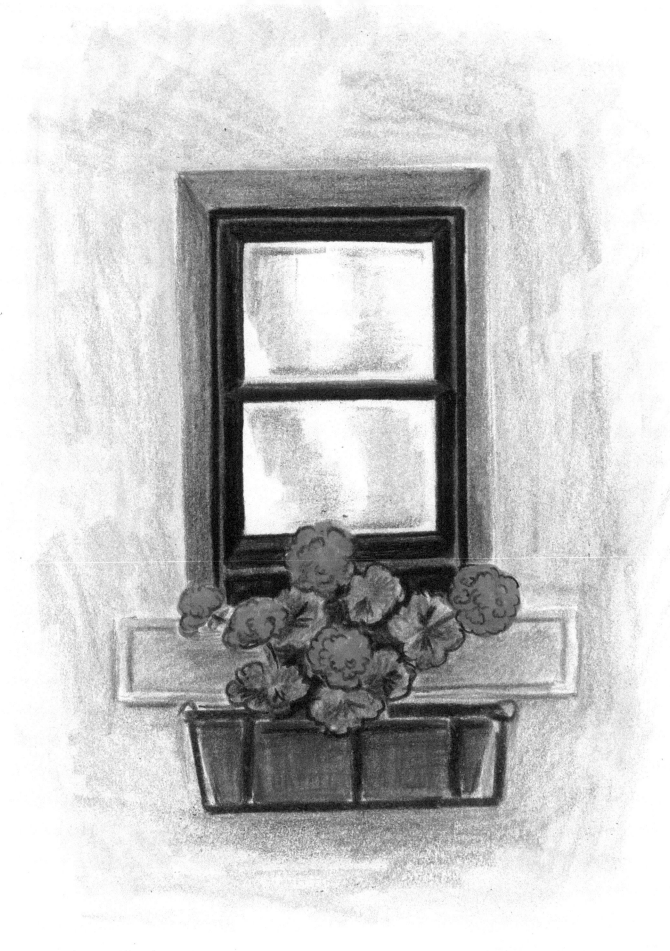

Add more texture to the plaster wall with your original tan colors, and even some slightly darker brown shades. Sharpen a dark brown pencil to add detail to the geranium flowers and the flower box.

BRICK WINDOW

Watercolor pencils are a great option when you encounter more detailed architectural details, especially brickwork. While you can still achieve great detail with regular colored pencils, watercolor pencils can speed up the process!

Start by outlining your window lightly with pencil. Begin with the basic shape; you will add the bricks after establishing the shape and size of the window. Keep an eye out for any instances of skewed perspective where the frame or bricks are angled toward the sky, the viewer, or the ground. This will vary according to the angle from which you're viewing the window.

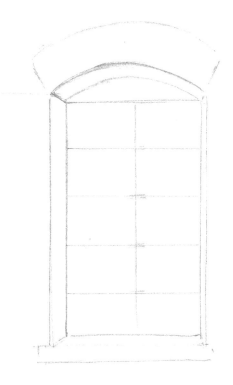

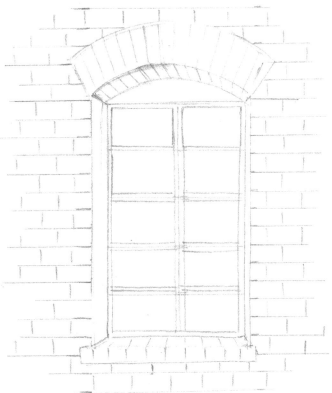

Still working with regular pencil, lightly sketch in the bricks. Bricks are usually a consistent size and shape, but there are, of course, some variations. Draw the angles of any bricks on the arches, sides of the windows, and ledges.

BRICK WINDOW COLOR SWATCHES

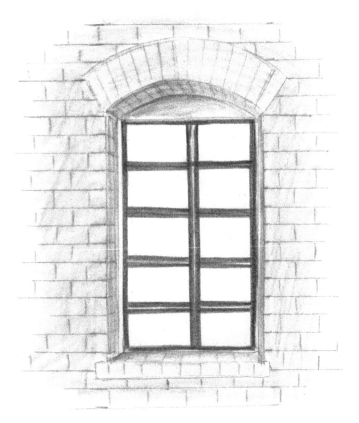

With watercolor pencils, roughly shade in the bricks all over with light brown and tan. You can do this by laying the lead on its side or working with dull pencils. Don't worry if pencil marks show; these will be blended with water. Do your best to avoid getting any color on the windowpanes.

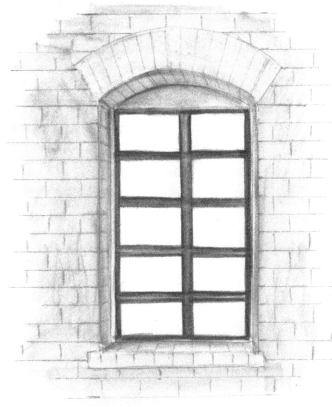

Using a brush with clean water, blend the first layer of colors. If you're using regular drawing paper, keep in mind that you will only be able to add a couple layers of water before your paper begins to buckle or break down.

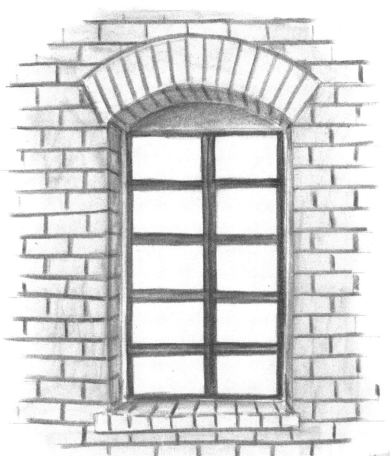

With a medium gray pencil, go over your original pencil lines to shade in the grout between the bricks. You can also shade in the underside of the arch and the sides of the window frame. This is best done with a dull pencil instead of a freshly sharpened one. Use light blue to add a little color to the windowpanes, preserving the bright white paper for the highlights.

Using red-browns, yellow ochre, and varying shades of gray and brown, add texture to your bricks. Not all the bricks need to be identical, so you can layer in the color sporadically to show the varying colors.

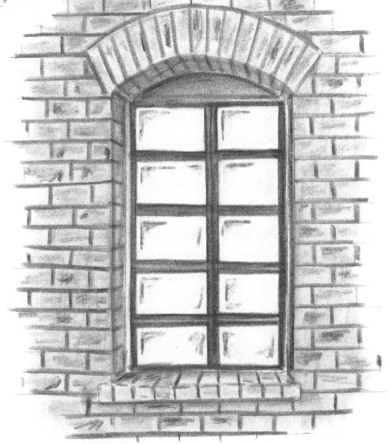

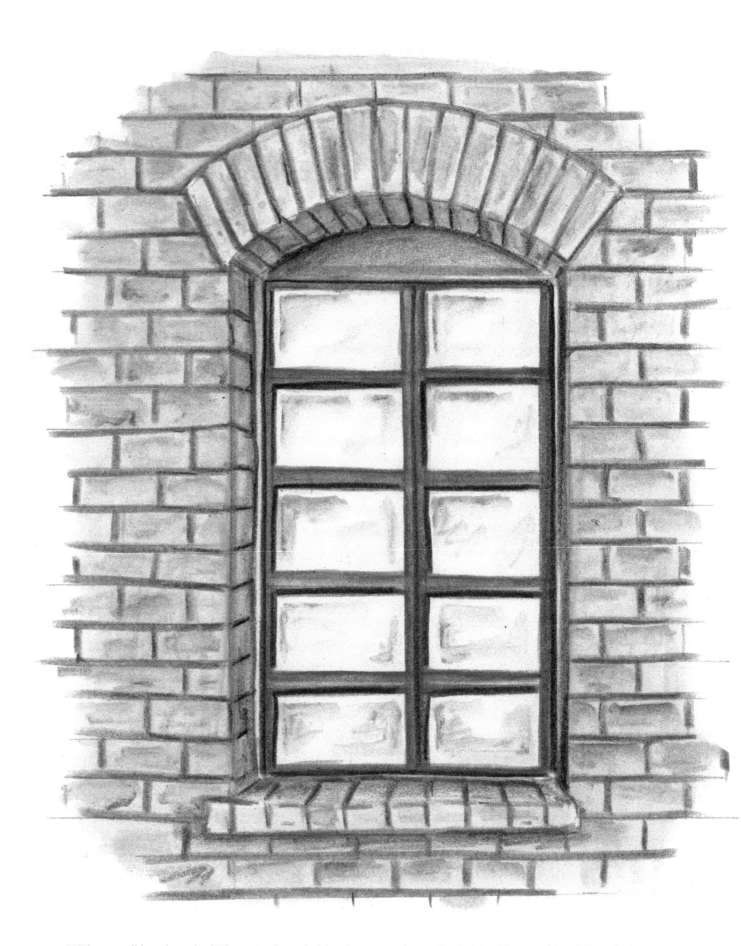

With a small brush and a little water, loosely blend your marks on the bricks. You can blend the windowpanes as well. Add any last shadows to the grout and under the arch and ledge.

DOORS

Doors and doorways also make great sources of inspiration. Especially in older countries, doors appear massive and ancient! Many include lots of unique textures and details.

Break down the door into its basic shapes with pencil first. For this arched doorway, start with the simple lines of the outer arch.

From my vantage point, the door is at an angle, so I can see inside the archway over the door. This inner archway matches the first outer shape, but it's pushed back into the frame a little bit. Lightly add details to the door.

Sketch the final details on the door and the brickwork along the upper arch. Pay attention to the angle of the bricks in the inner arch, and note the perspective skew.

DOORWAY COLOR SWATCHES

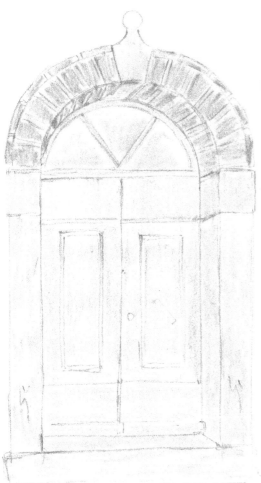

Loosely sketch in the first layers of color on the bricks, columns, and door.

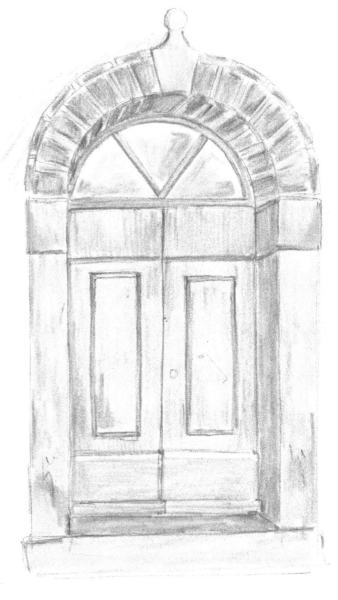

With the same colors as before, press a little harder to add another layer of color in areas that need more shadows. In areas that need to be even darker, start layering in darker shades and dark gray.

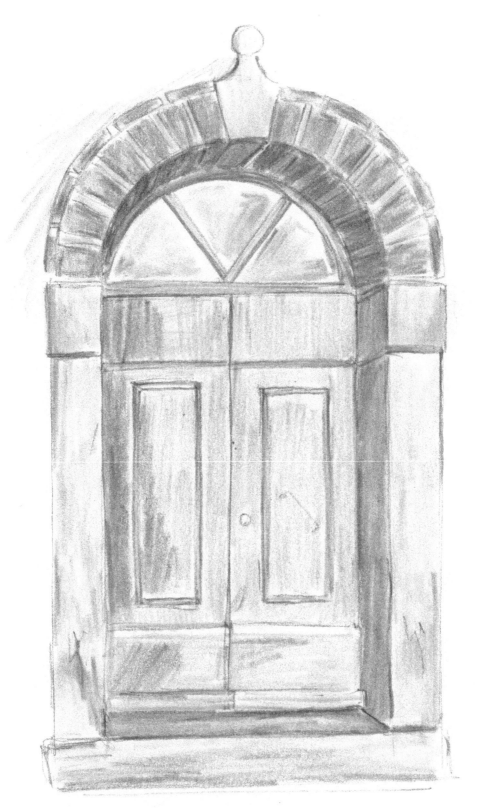

With dark brown, begin adding more defined shadows and details to the brickwork. Make sure the brick faces along the inner arch all follow the proper lines of perspective.

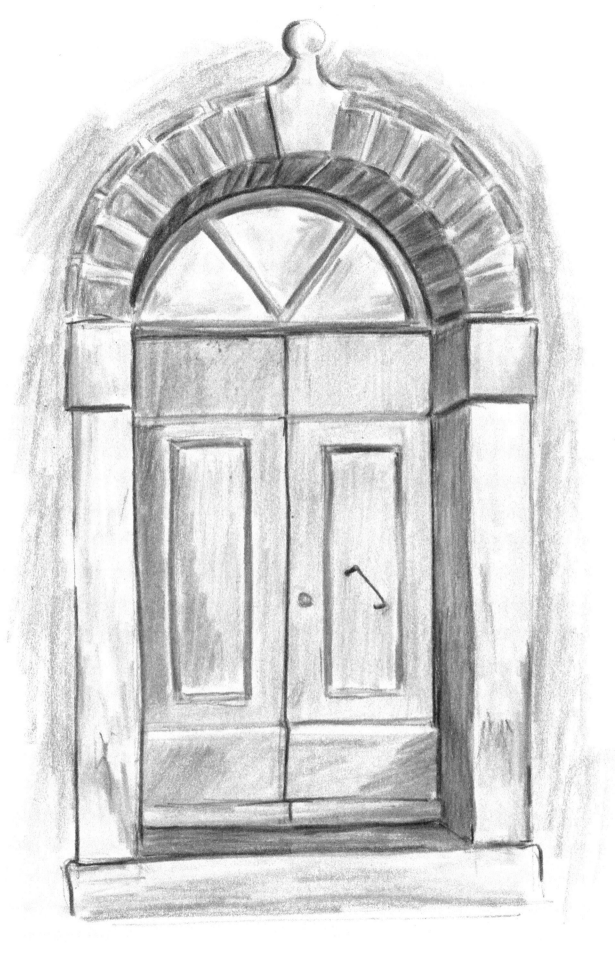

Using a black pencil, define the edges of the bricks and along the columns. You can also use light layers of black on the door for shadows, or even a darker shade of blue.

You can also use color to help isolate and "draw" white architectural details by preserving the white space of your paper. Especially for white columns, window frames, or doorjambs, preserving the white space next to a brightly colored door or house makes for an even brighter pop of color!

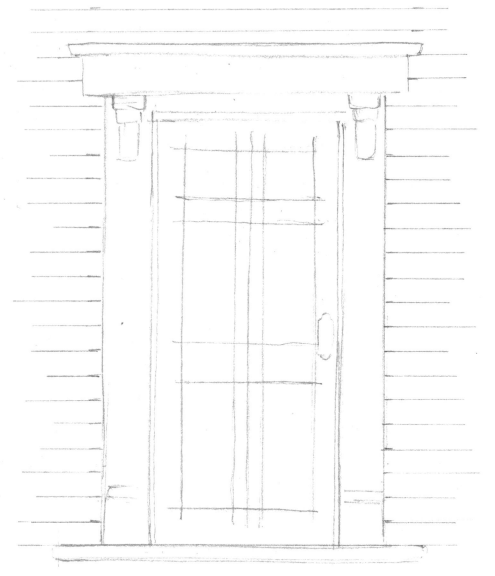

Outline the doorframe, including the jambs, threshold, and entablature above the door, lightly in pencil. You can use a ruler if you prefer to get your lines nice and straight, but freehand works too! No ruler? Grab a scrap piece of paper, fold it in half, and use the stiffened fold to guide your pencil like a ruler.

Then start to break down the panels on the door into basic shapes and add the details to the top and bottom of the doorjambs. Measure or estimate equal distances for the siding on the house and sketch those loosely.

RED DOOR COLOR SWATCHES

Finalize the details on the door panels and erase any unnecessary stray lines.

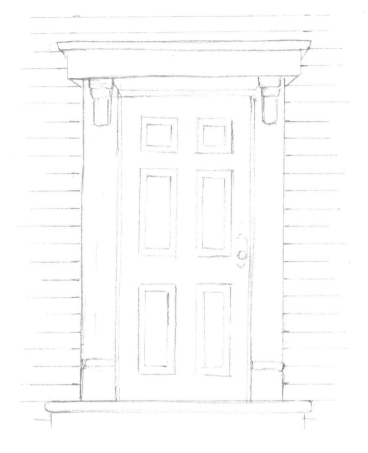

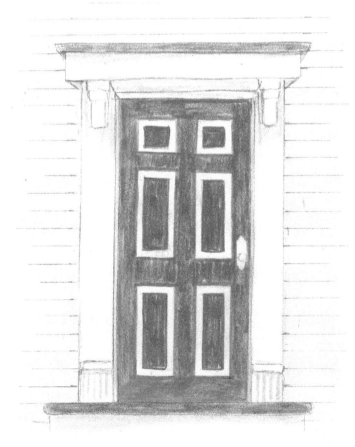

Add your first layers of color to the house siding, door, and the cornice and threshold around the door. With light gray, gently shade around the decorative accents on the doorjambs.

Use yellow ochre to add the shadows cast by the siding along the house. With a darker gray, start building up the shadows on the decorative details on the doorjambs. You can also layer in more red on the door to make it a richer shade.

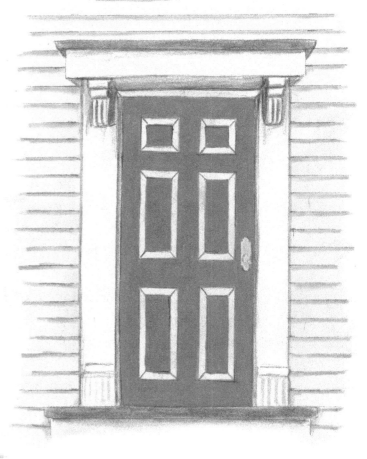

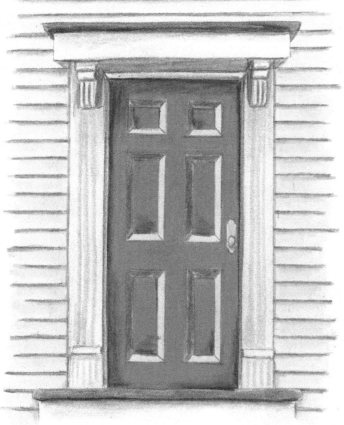

With dark brown, start burnishing some shadows onto the door in the upper corners and in the crevices on the panels. Using gray, add more details on the doorjambs. As you color and shade, you may transfer and spread your brighter colors into the white areas. This is OK! You will go back in and erase some of this color at the very end.

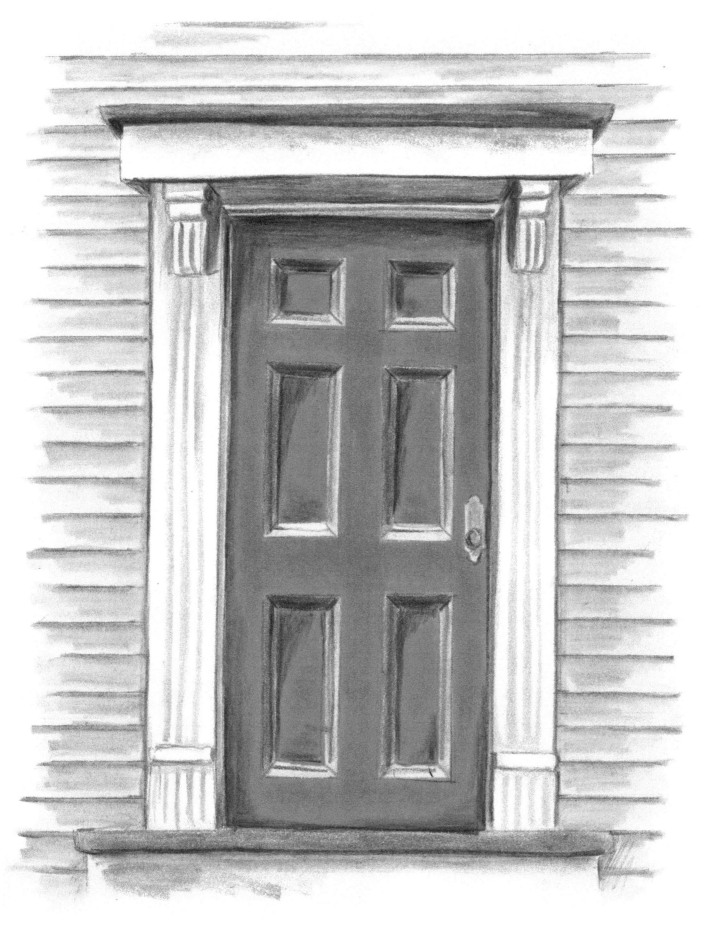

Time to get those shadows to pop! With a darker yellow, add more shading on the siding of the house. Darker gray and a little black will give the white areas more contrast. When you're finished adding color, grab an eraser pencil or eraser pen to rub away some of the transferred color and pull the bright white highlights back out.

It can be a fun challenge to draw
architectural details on toned
paper. Working on toned paper
has the added benefit of giving
you a color to work with from
the get-go. While white paper
is your automatic highlight,
working on toned paper gives
you automatic midtones or
shadows, depending on the
darkness of the paper.

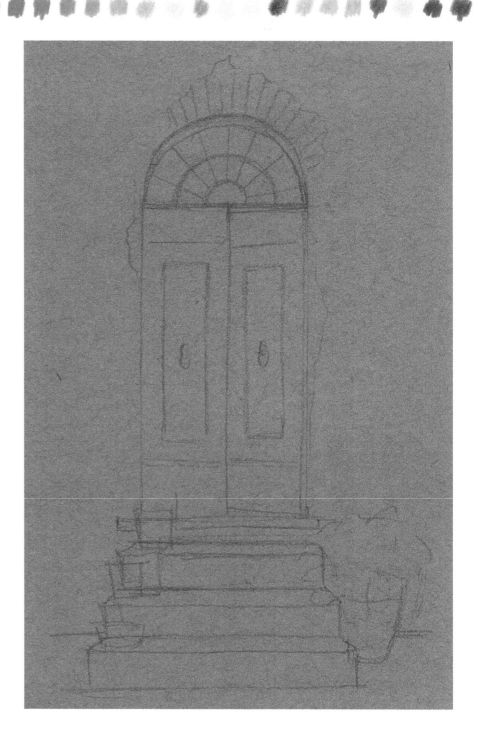

Sketch the outline of the door
and window above it, and lightly
indicate the surrounding plants
and steps. Add more detail to the
door panels and the brickwork
in the wall. Develop the stairs
further, paying attention to the
angle of each as they come
closer to the viewer.

TONED DOOR COLOR SWATCHES

Clean up your drawing and finalize your pencil sketch so you can start to add color.

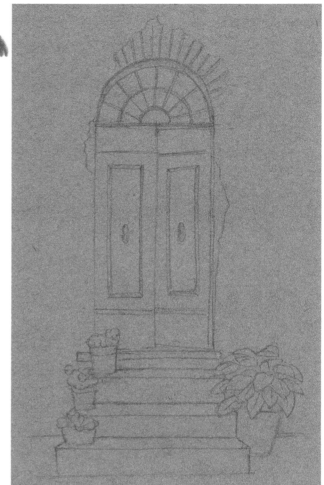

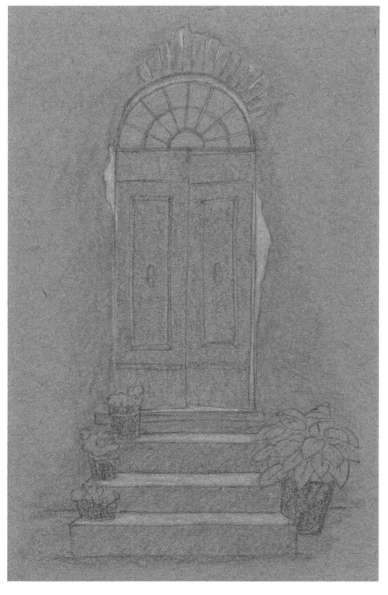

Lightly add your first layers of color on the wall, door, steps, and plants. These first colors should be closer to your highlight colors; you will add more color to the darkest shadows as you go. Just like working on white paper, the darkest shadows should be developed last!

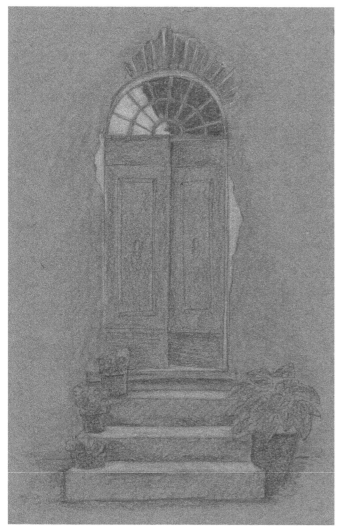

Start to build your shadows, but slowly! You don't want to go too dark too quickly. These layers can also add texture to the door, steps, and wall.

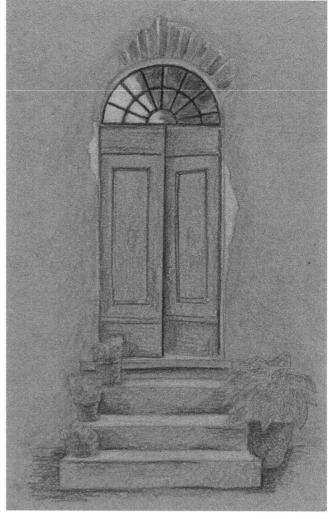

With dark browns, umbers, and even a little black, start developing the darkest shadows along the edges of the door, the window grate, and on the steps. Build up more layers and texture on the door and plants.

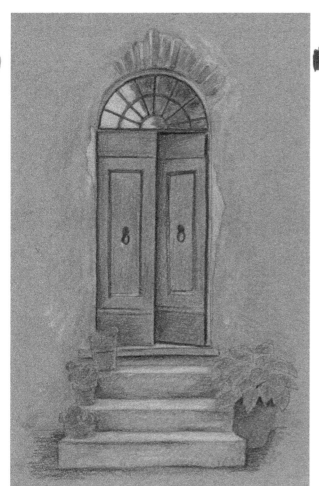

Using grays and some warm browns, develop the steps and doors a bit more. Add in the greens and reds to the geranium flowers along the steps.

With dark browns and blacks, burnish your darkest shadows and add more subtle shadows around the base of the plants and steps. Shade the leaves to give them more dimension. You can also go back in with white and light tans to add brighter highlights along the steps, wall, and doorway.

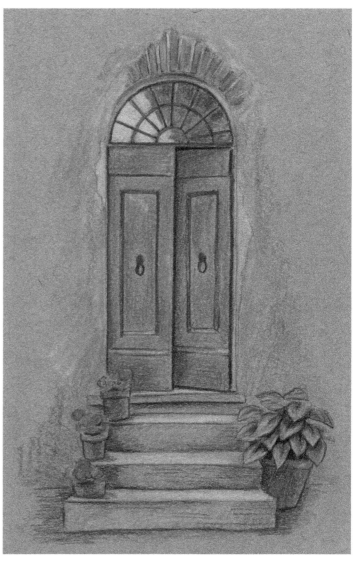

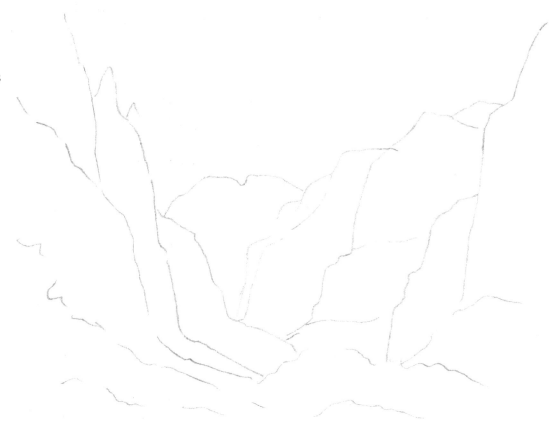

LANDSCAPES

While buildings and architecture are some of my favorite subjects to draw, it's fun to loosen up from time to time with landscape studies. Compared to buildings, landscapes are much more forgiving! Since they depict nature, they should be loose and organic to reflect the organic nature of what you're studying.

I love to sketch national parks when I get to visit them, especially the rock formations of Zion National Park in southern Utah. The colors of the rocky canyons are a great exercise for color blending and showing the depth of the canyon.

In regular pencil, lightly and loosely sketch the rock faces and layers as they descend into the canyon.

ZION COLOR SWATCHES

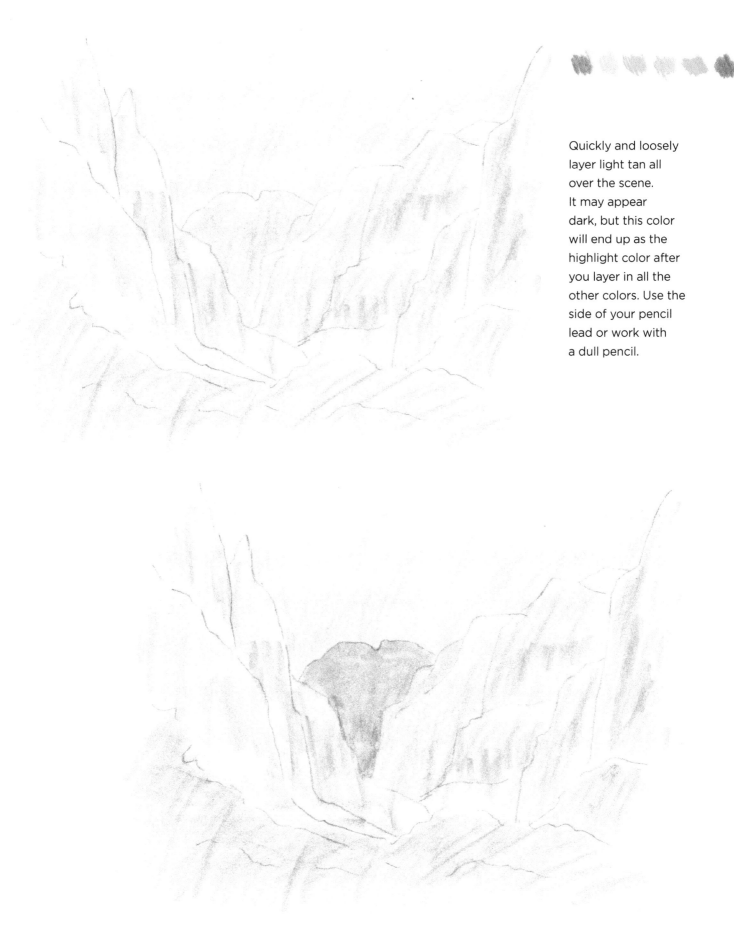

Quickly and loosely layer light tan all over the scene. It may appear dark, but this color will end up as the highlight color after you layer in all the other colors. Use the side of your pencil lead or work with a dull pencil.

Using sap green, start adding quick gestures of color on the foliage along the bottom of the canyon. With light gray, lightly shade in the ridge farthest in the distance. Make sure you use light gray, and shade it in lightly! It will look dark on the page at first, but you will build up the colors and shadows to make it appear lighter in the end.

Moving on to the next-closest ridges, shade them with a slightly darker gray. Build up the yellows and browns in the other ridges, and even in the foliage and trees along the bottom.

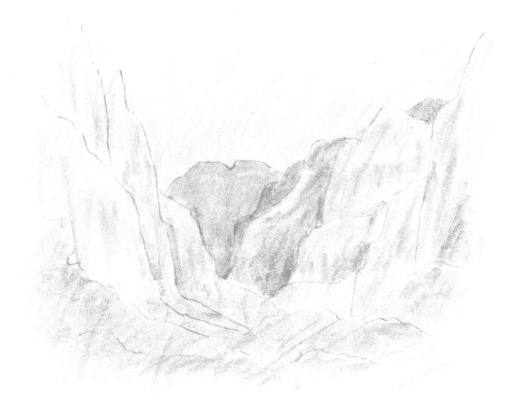

Time to make the foreground ridges pop! With dark grays and rich red-browns, make quick and bold strokes to show texture and layer in the shadows.

As you layer in these darker colors, that first layer of light gray on the distant ridge will slowly recede into the back of the scene. By leaving that first layer light, subtle, and without texture, you naturally push it into the distance and build up the atmosphere of the scene. Adding more texture to the closer ridges and the plants below will bring these areas closer to the foreground.

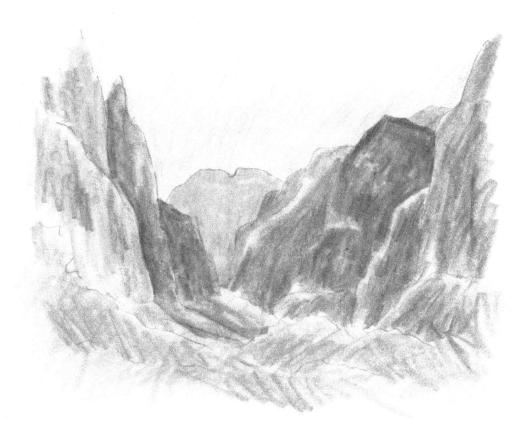

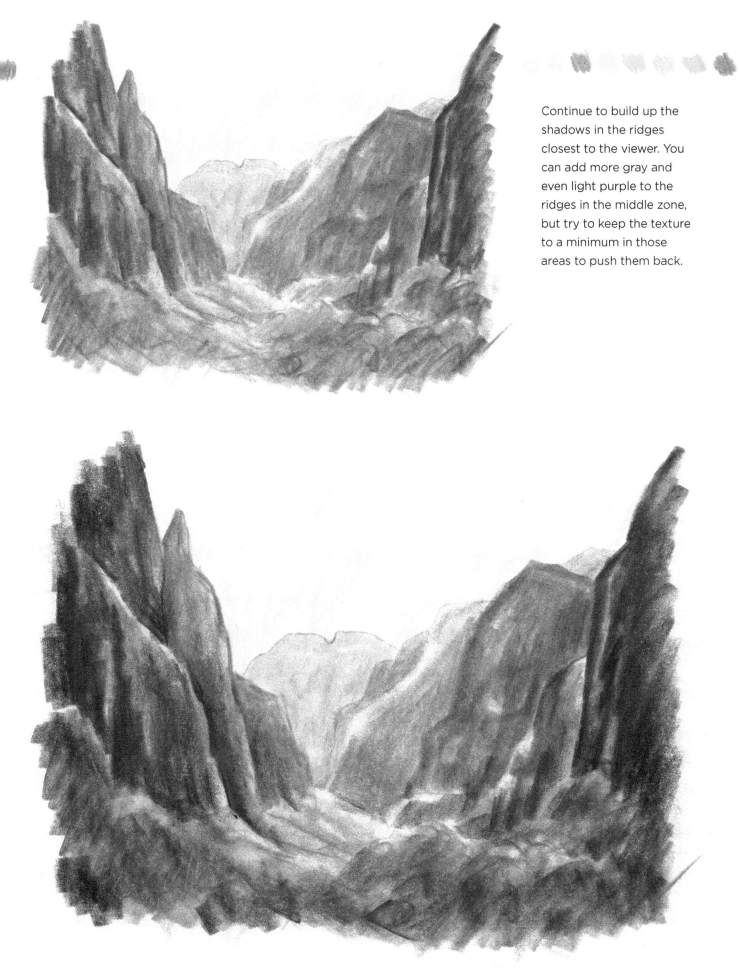

Continue to build up the shadows in the ridges closest to the viewer. You can add more gray and even light purple to the ridges in the middle zone, but try to keep the texture to a minimum in those areas to push them back.

With your darkest browns and some black, burnish in the darkest shadows on the rocky cliffs and the foliage below.

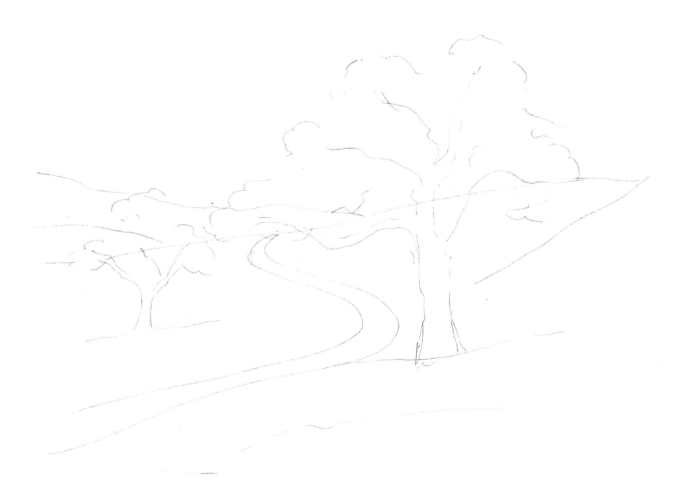

To loosen up even more, use watercolor pencils! With watercolor pencils, you can quickly add a variety of colors to the page and blend them together to build atmosphere in your piece and background layers. Once dry, you can add the fine details to make your landscape really stand out.

Sketch your scene lightly in pencil. Your trees can overlap the horizon line and other details, since these will be added last using darker colors. Keep in mind that if you use regular paper and add too many layers of water, your paper will buckle! If you plan to add more than two layers of water, I recommend drawing your scene on thick card stock or watercolor paper.

GREEN HILLS COLOR SWATCHES

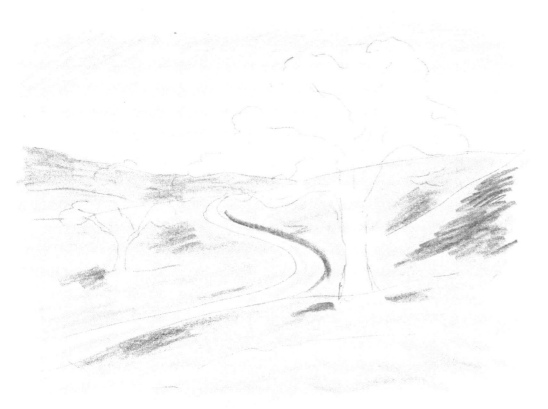

With dull pencils, or using the lead on its side, loosely layer in the first layers of light green, yellows, and dark green on the grassy hill. Add purples and blues to the sky, keeping the darker concentration of blue toward the top the sky since the sky lightens as it nears the horizon line.

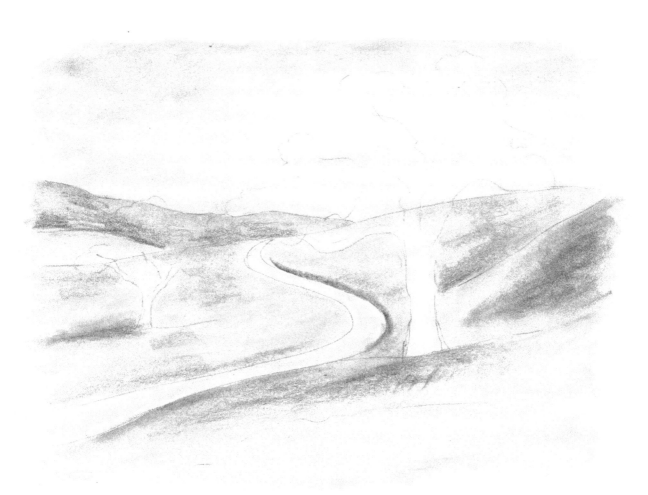

With a brush and clean water, blend each area. Do the sky first, since it's the lightest, and then move on to the darker areas. Try to leave the trunks of the trees blank so you keep the white paper to help add highlights to the bark. You can also achieve a similar look by blending oil-based pencils with some distilled turpentine.

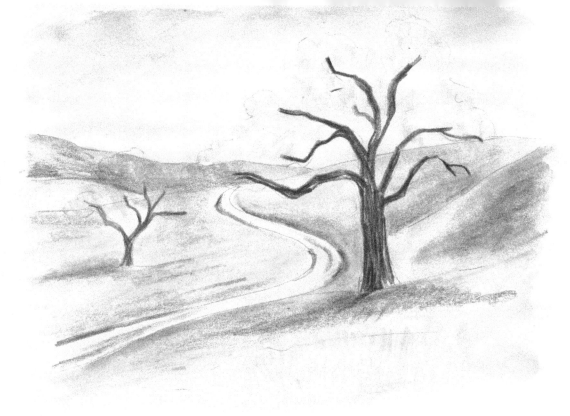

When your paper is dry, add more layers of green into the hills to build the shadows and texture and make the colors richer. With shades of brown, start coloring in the trunks of the trees and branches. Loosely add in some of the foliage of the trees with light greens first.

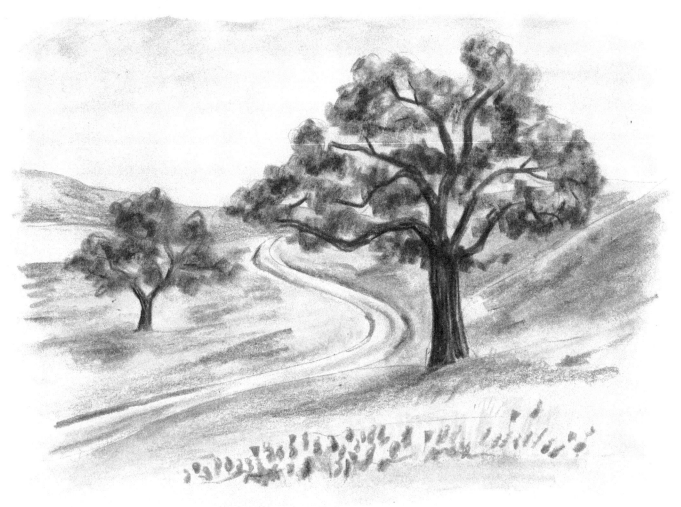

Add in the darkest colors in the tree trunks, branches, and foliage. To add wildflowers along the hills, use a dull pencil or the side of your pencil for the flowers on the distant hills. Use a sharpened pencil for the flowers, grass, and details in the foreground.

If you have a particularly busy or complex landscape scene to draw, you can simplify it by limiting your colors to one or two. This will make your landscape study a value study instead of an exercise in color matching. I find that these studies are faster to create, because I don't get caught up in the little details or colors.

You will, of course, sketch your scene in regular pencil first!

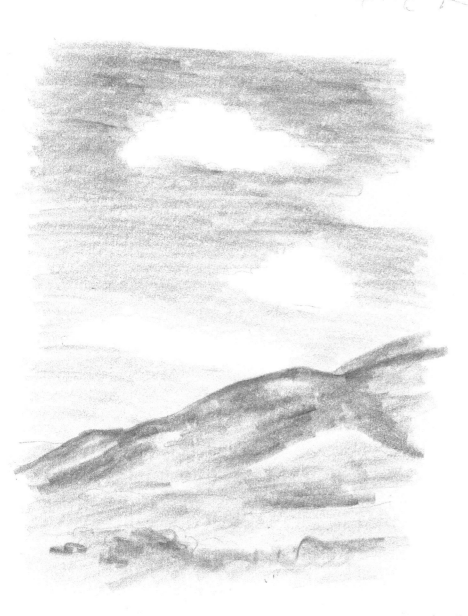

This study features a sepia tone, but you can pick any color. With the side of the lead, shade in the lightest areas all over your piece, and preserve the white space of your paper for any highlights or clouds. Build up the darker areas once you have the lighter areas shaded in for comparison.

Resist trying to draw every single tree in your scene. Rather, focus on the value shifts from light to dark in the sky and mountains. In areas where you do need to add detail, to show changes in direction of fields or roads, use broad strokes to keep your piece loose and flowing. Add another layer of color to the top of the sky. You can add a little texture to the clouds too, but only add a little at a time, and pause often to make sure you don't add too much.

DRAWING ANIMALS

Animals come in so many different sizes, types, and colors, so they make ideal subject matter for drawing. While you still have the challenge of drawing a moving creature, drawing animals is a great exercise, whether it's paws and tails or claws and beaks!

Drawing animals from life can be tricky, since animals rarely hold still long enough for you to start and finish a colored pencil drawing. You can, of course, take photos to use as reference for more detailed drawings. If you want to draw a particularly active animal from life, another method of drawing is gesture drawing and color studies. Let's explore that first!

GESTURE DRAWING

With gesture drawings, you quickly capture the animals' movements on the page by breaking them down into basic shapes and adding loose marks to indicate their movements, curves, and shifting tails/ limbs. These gesture drawings shouldn't have much detail, like eyes or fur texture, but rather convey the animals' movements and shape before they shift to another position!

After you complete your gesture drawings, you can develop them further with simple color studies. Pick three colors of the same color family: one to represent the highlights, one for the midtones, and one for the shadows. With your colors selected, add the highlights all over your drawing. Then progress into the midtones and shadows with the other two colors. Your drawings will be simple value studies, with shifts from light to dark all over the animal! These are good warm-up exercises before starting more detailed animal studies.

CATS & DOGS

If you couldn't tell yet, my personal favorite animals to draw are cats!
Their furry and sweet faces are hard to resist, and they have so much personality.

Start with regular pencil and break the cat down into basic shapes and loose lines. Don't get caught up in drawing any of the fine details yet, like whiskers. These should come later in the drawing, after you've finalized the size and shapes of the animal.

Clean up your drawing and add more details in pencil, like the eyes, toes, stripes, and whiskers. You can make notations of fur direction or dark/light areas of fur too.

With a light gray pencil on its side, lightly shade in the paws, tail, and any shadows on the face and chest. This cat, in particular, has lots of white fur, so be conservative and selective as you add color to the fur. You can shade in around the base of the cat too. Lightly add color to the eyes and nose.

CAT COLOR SWATCHES

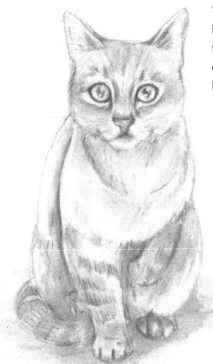

With a darker gray, start building up the shadows on the cat under its limbs, along the tail, and on the stripes. These marks can also start building texture in the fur, so they should follow the natural direction of fur growth on the cat. Add some warmer tones in the face, and build the layers in the light blue eyes and the nose.

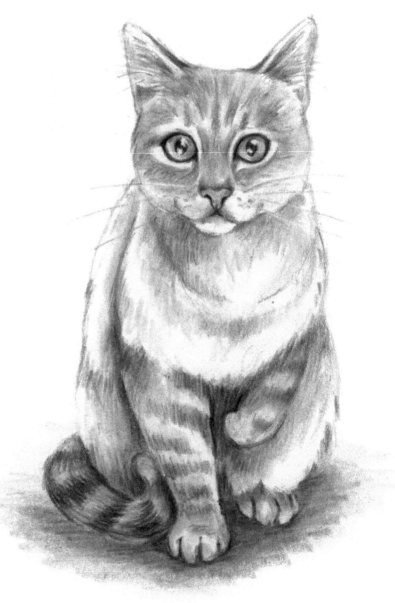

With your darkest gray and a little black, add quick strokes to the darkest shadows to build more textured shading. Sharpen your pencil to add the dark ring around the eyes, nose, ears, and even whiskers. Add more texture to the stripes along the tail and the paws. If you've smudged too much color on areas of the fur that should be brighter, use an eraser pencil or eraser pen to pull out some of the highlights and add textured highlights to the fur, if desired.

Dogs can be particularly challenging to draw because they're such active animals. While getting them to hold still with the promise of treats is a great way to snap a photo, you can also get a unique foreshortened angle to draw from this way!

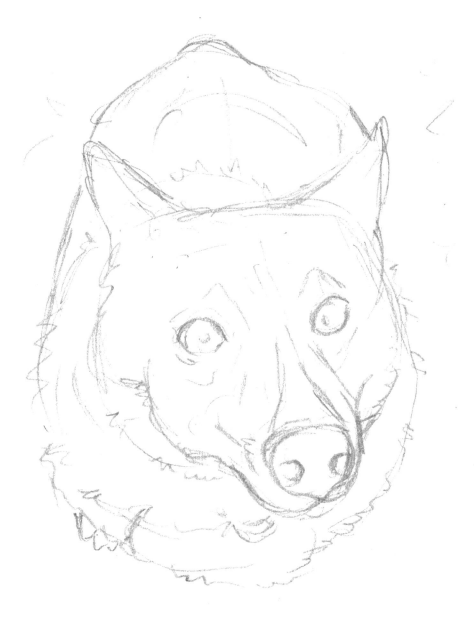

Snap your photo and study it closely before you start sketching. If possible, blow it up on your computer so you can see it more clearly. At this angle, the head appears to be nearly as big as the rest of the body, and having a larger photo will help you sketch the proportions more accurately.

DOG COLOR SWATCHES

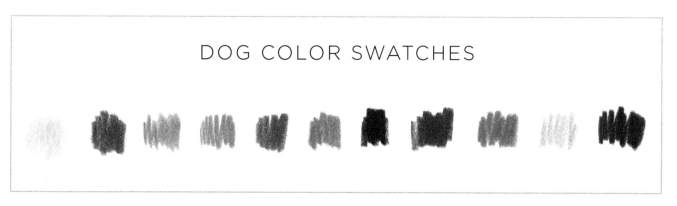

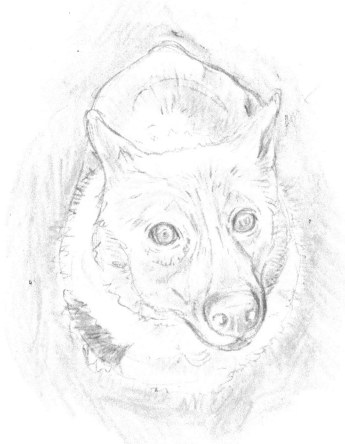

With light gray, add quick strokes of gray along the lower and darker portions of the body and across the face. Make sure these strokes follow the direction of fur growth down the body and as they curve across the face and nose. For the ground below the dog, keep it loose and choppy, since it won't have much detail in comparison to your focal point: the dog's face!

Build up the warm tones in the fur by layering in strokes of dark and warm browns, and even some yellow on the face. You can add yellows in the eyes as well.

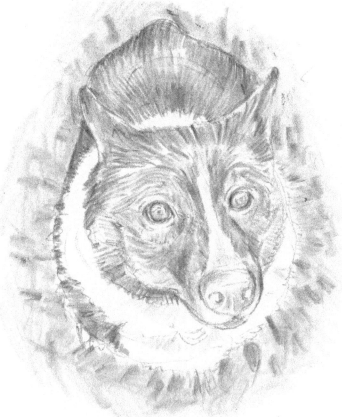

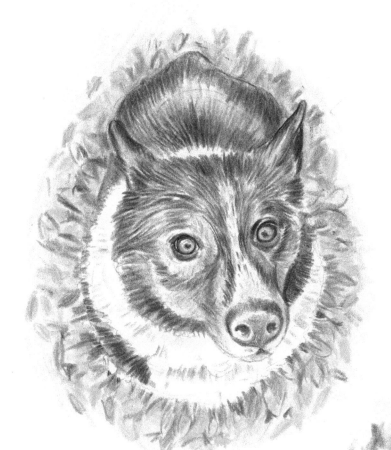

With a sharpened black, start adding strokes of black on the darker portions of the fur. Don't add so much that you obliterate the lighter colors and layers though! These should layer in texture but not become an opaque layer of black. Outline the eyes and shade in the pupils, preserving the white highlights. Build up the shadows on the nose, especially inside the nostrils.

Again, with your black pencil, burnish in the darkest areas while still adding texture. With the black, you can layer in more brown and yellow to help keep the layers warm. Use a finely sharpened gray or black pencil to add the dog's whiskers and fine furry details along the face. Add more autumnal colors to the leaves below the dog, but don't worry about adding any details or defining lines; the leaves should stay blurry and out of focus, so the dog is the focal point!

For a particularly hairy dog, a fun option is to use watercolor pencils. This allows you to layer in color quickly and gives you the ability to add texture on top when it's dry. I recommend working on 140-lb. watercolor paper so you can apply multiple layers of water to blend the layers.

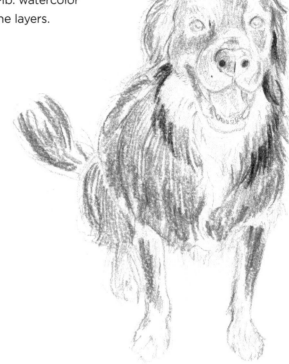

Add the first colors loosely, avoiding any areas of white fur.

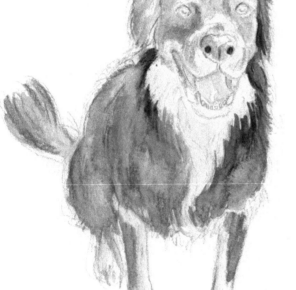

Blend the first layers with a brush and clean water.

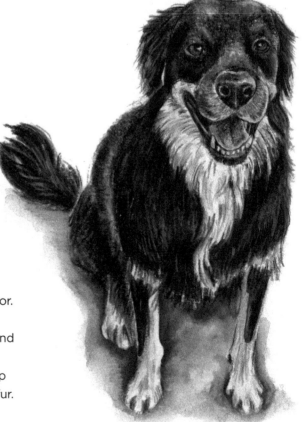

Once dry, layer in more strokes of color. Blend with water, and allow it to dry before adding the darkest shadows and colors to build the texture of the fur and add color to the coat. Use a sharp white pencil to add highlights in the fur.

BIRDS

Birds are another great option for more detailed drawing studies. Pigeons, crows, sparrows, and even seagulls are great options, since they're usually pretty easy to spot in the wild and snap some photos of to use for reference. They also have very simple shapes!

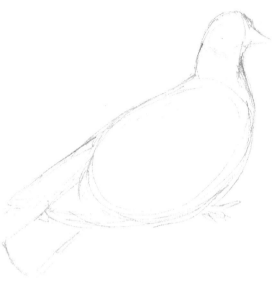

Find your bird and start breaking it down into basic shapes in regular pencil on your paper. Most birds' bodies are a large oval, with a round head and triangular protrusions for the beak, feet, and wingtips. Shown here is a pigeon.

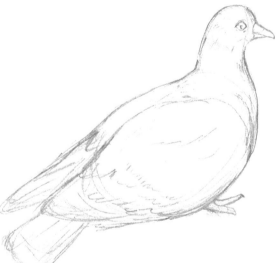

With your regular pencil, smooth out the outlines of the pigeon so they're round and curve around the neck, head, and chest. Sketch in details on the wings and any notes for shadows or highlights.

While pigeons have very dark wings and bodies, you'll want to build that up slowly and with multiple colors to show the iridescent colors hiding in the wings! With light gray, shade in most of the body, except areas that have highlights. Use some warm browns to shade where the darkest shadows will be. On the beak, feet, and eyes, add light layers of dark yellow tones.

PIGEON COLOR SWATCHES

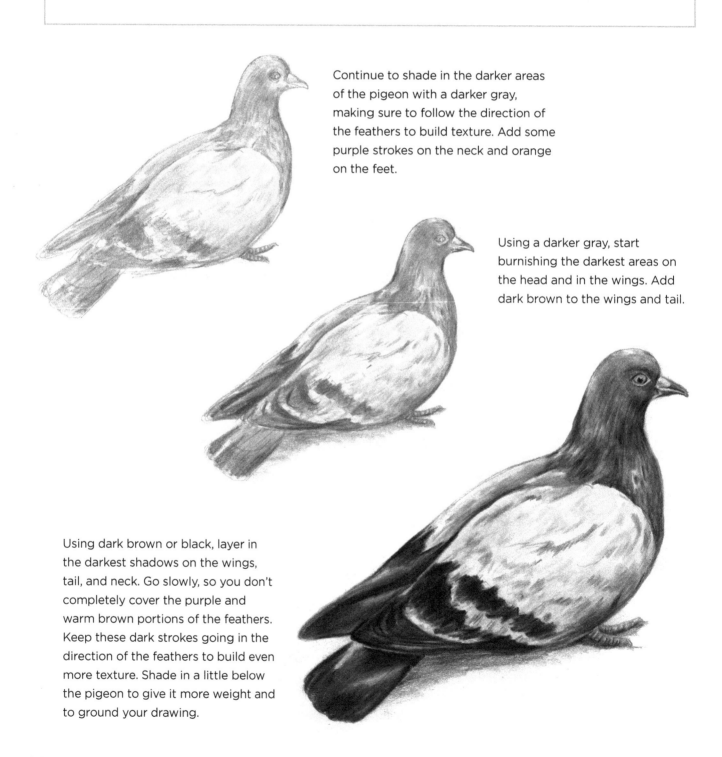

Continue to shade in the darker areas of the pigeon with a darker gray, making sure to follow the direction of the feathers to build texture. Add some purple strokes on the neck and orange on the feet.

Using a darker gray, start burnishing the darkest areas on the head and in the wings. Add dark brown to the wings and tail.

Using dark brown or black, layer in the darkest shadows on the wings, tail, and neck. Go slowly, so you don't completely cover the purple and warm brown portions of the feathers. Keep these dark strokes going in the direction of the feathers to build even more texture. Shade in a little below the pigeon to give it more weight and to ground your drawing.

GIRAFFE

While domestic animals are fun to draw, it can be nice to mix it up with the challenge of an exotic animal. If you can visit a zoo, I highly recommend taking along a camera or sketch pad to do some studies of more unusual animals that you might not often get to sketch from life. If there's no zoo near you, find some unique animal photos online to use as reference for an exotic animal study.

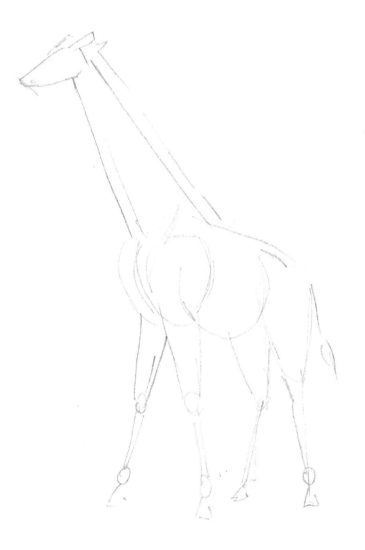

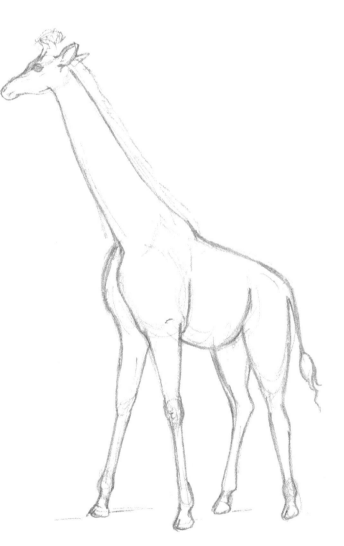

Especially if you are drawing a more complex animal, like a giraffe, take your time sketching to get all the proportions right! These first sketches can be loose and quick, almost like a gesture drawing.

Add in more detail and smooth out your lines. Giraffes are odd, because they can be quite curvy and angular at the same time. Look for unique characteristics like this in whatever animal you're studying.

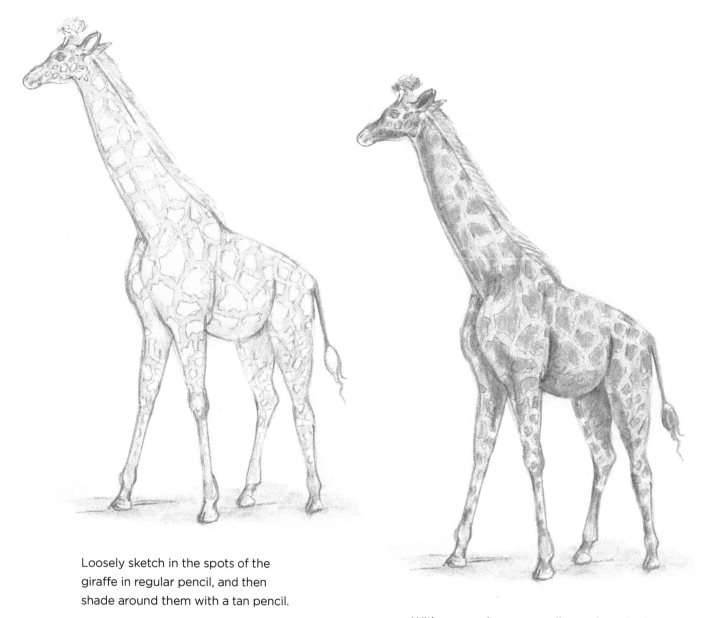

GIRAFFE COLOR SWATCHES

Loosely sketch in the spots of the giraffe in regular pencil, and then shade around them with a tan pencil.

With a warm brown or yellow ochre, shade in the spots of the giraffe. Use gray to build the shadows under the giraffe and along the neck and insides of the legs.

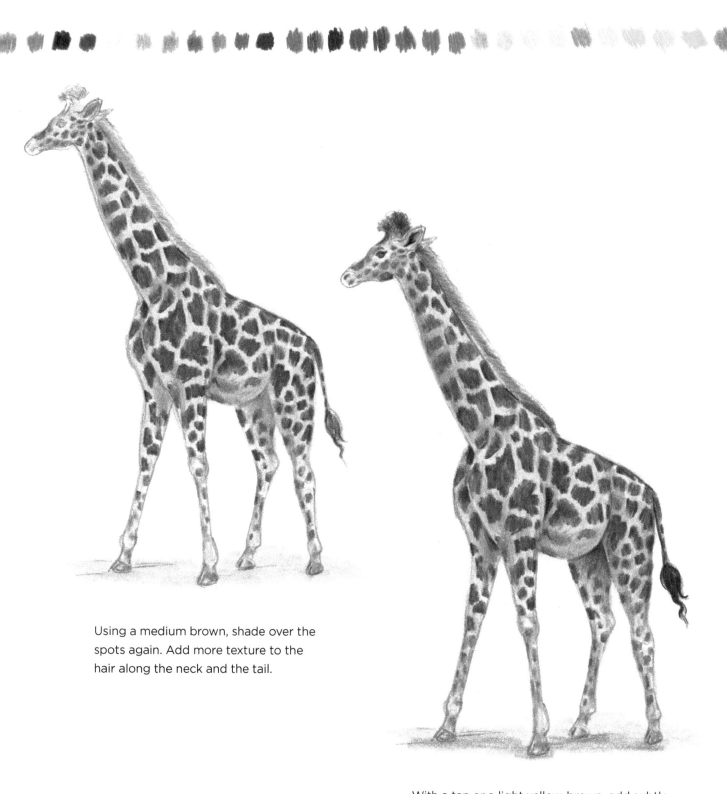

Using a medium brown, shade over the spots again. Add more texture to the hair along the neck and the tail.

With a tan or a light yellow-brown, add subtle shadows on the lighter areas to show the musculature of the legs and neck. Use dark gray to get the shadows in the inner legs and crease to "pop." Layer a little black and dark brown into the tail, tufts of hair, and even some of the darker spots on the body.

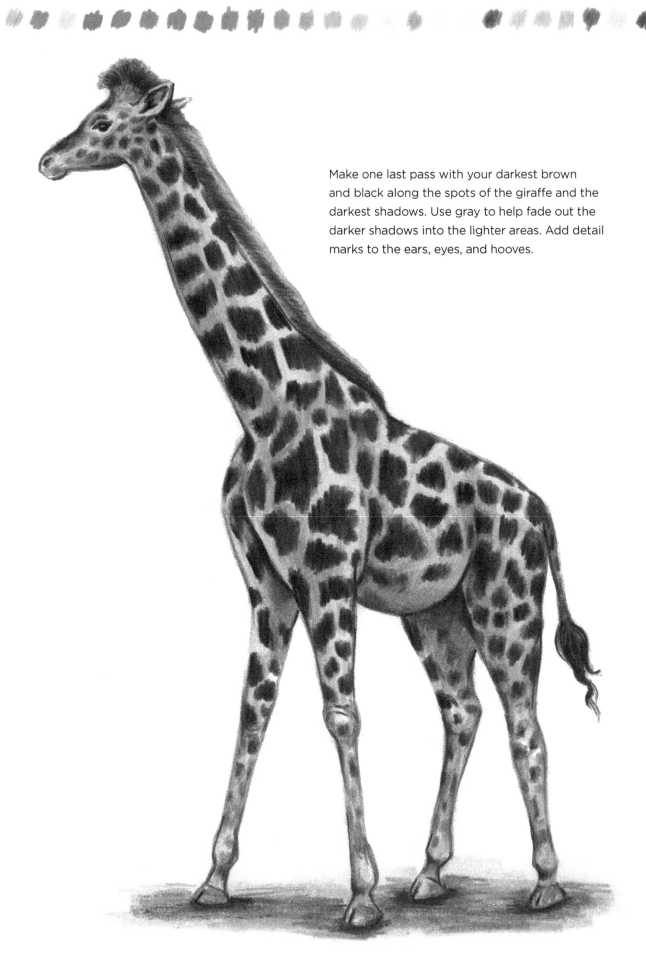

Make one last pass with your darkest brown and black along the spots of the giraffe and the darkest shadows. Use gray to help fade out the darker shadows into the lighter areas. Add detail marks to the ears, eyes, and hooves.

FIGURE STUDIES

People are one of the most challenging and rewarding subjects to draw. Like animals, people come in all shapes, shades, and sizes, which gives us plenty of options when looking for drawing subjects. It can be tricky to draw people realistically, because we often assume what they should look like, rather than studying people closely to see what makes them individuals.

Remember that every person you draw is unique, from one to the next. Steps you take to draw one person may differ when you draw another person, so take your time to study each subject and observe the characteristics that are unique to them!

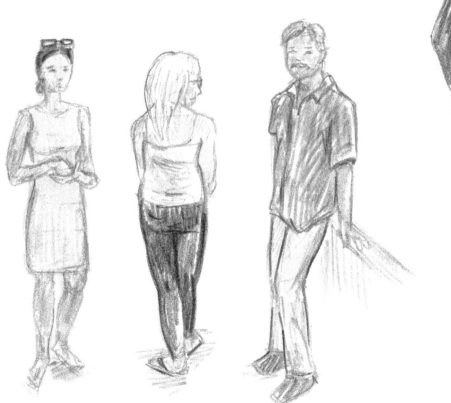

SKIN TONES & HAIR COLOR

A unique aspect of drawing people is the various skin tones—and the number of colors it can take to render one! If you look at this chart, you'll see a small sample of skin tones you can blend with colored pencils. Below each skin tone swatch are all the unique, and sometimes surprising, colors it can take to blend one skin tone!

This is far from being a complete chart of all the skin tones you'll see out in the world! Keep that in mind as you practice blending and drawing people, and experiment with creating other skin tones as well.

Skin Tones

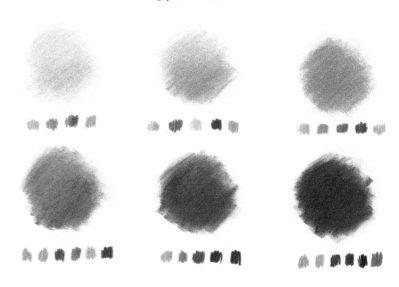

Hair color, as well as texture and length, can vary drastically from one person to the next. It's best to start with the lightest colors first and preserve any highlights as you build up the colors and texture of the hair. When applying color, use strokes that curve along with the strands of the hair to help convey the shape and texture.

Hair Colors

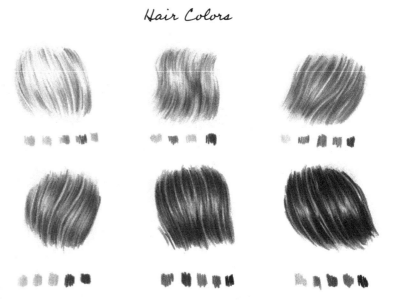

Don't try to draw each individual strand of hair. Doing so would look unrealistic—and take a really long time! Instead, look for shapes of value in the hair, and focus on creating the pattern of lights, midtones, and darks.

FIGURE PROPORTIONS

Some shortcuts will help you draw a figure more accurately. Knowing these shortcuts makes figure drawing a little less daunting.

You can use the length of a person's head to measure their height accurately. Most people are between seven and eight heads tall.

The width of a person's head can also help determine their shoulder width. Men tend to have shoulders that are three heads wide, while women's shoulders are generally two-and-a-half heads wide.

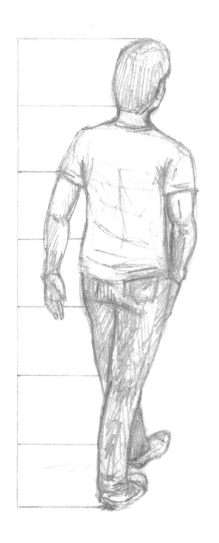
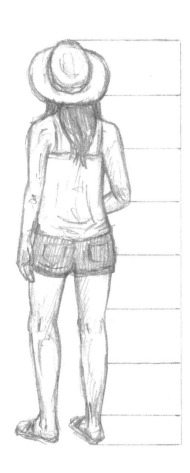

Knowing these proportions will help when you start sketching moving figures. In these moments, you'll have less time to focus on drawing the tiny details; rather, you'll need to catch their movements and proportions quickly with gesture drawings.

This facial chart breaks down the many measurements we can use to capture the accurate proportions of a person's face. While there are variations from one person to the next, these general proportions are fairly accurate across most people's faces.

After sketching the outer shape of the face, draw a line straight down the center. This line doesn't necessarily mean the face is mirrored on each side, but it will help you get everything centered. From there, draw the purple lines that divide the face in two horizontally, from the very top of the head to the bottom of the chin. Along this line, in the center of the face, is where the eyes fall. The average person's face is five eyeballs wide from the side of one ear to the other. The green lines show five equal spaces, including one in the center between the two eyes.

You can also divide a person's face into thirds: the top of the forehead to the eyebrow line, the brow line to the base of the nose, and the nose to the chin. This blue line helps measure the size of the ears, as most people's ears start at the corner of the eyebrow and end around the base of the nose.

Many noses are the same width as the one-eyeball measurement in the center of the face. The center of the eyes also helps in guiding the width of the mouth when you draw lines from the center of the eyes straight down the face toward the mouth.

The bottom third of the face can be further divided into thirds (the red lines) to determine the center of the lips and chin.

Of course, not all these measurements are exact on every face, but they're a good guide to help you capture all the features relatively in the proper place.

GESTURE DRAWING

Just like with animals, gesture drawings are a great way to capture a person in motion. Unless you have a model posing for you, people are generally on the go and don't maintain a position long enough for a detailed portrait drawing.

Make quick strokes with your pencil to note the angle of their posture, the tilt of their head, the angle of their hips, and even the direction in which their feet are moving. Gesture drawings of figures shouldn't include too much detail in the faces or hands—at most, just some guiding lines in the center of the face, horizontally and/or vertically, to hint at the direction the face is looking and where the eyes would be if you decided to develop the drawing further. It can be helpful to sketch gesture drawings on graph paper to help measure the proportions without having to stop and measure with a ruler or your hands mid-drawing.

These gesture drawings can turn into more developed drawings too. Rather than drawing with colored pencil at first, sketch your figures with regular pencil. This time, make more notes of their features: eyes, noses, mouths, hair, and even their hands and clothing.

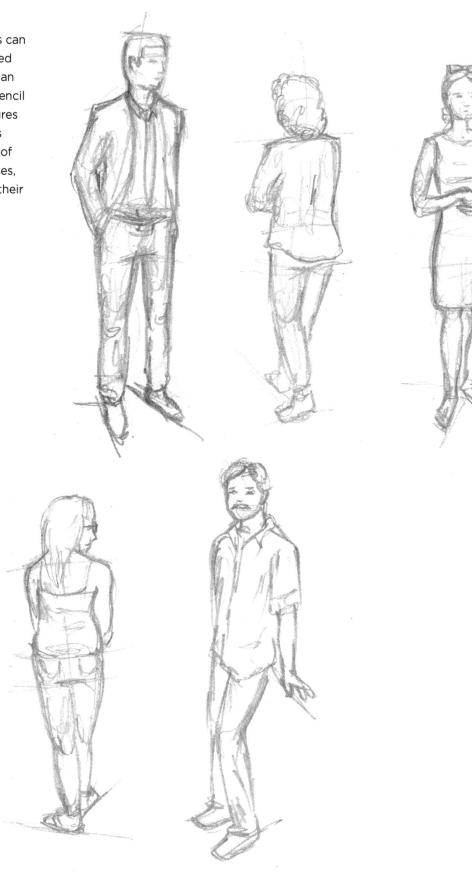

Similar to gesture drawing,
add color quickly and loosely,
using quick strokes to create
the clothing colors, skin tones,
and texture for hair. These hatch
marks can help convey movement
and the direction of the clothing
and hair. These do not need to
be finished-looking, detailed
drawings. Rather, these are
quick figure studies to catch that
moment, or studies to inform later
in-depth drawings. These can even
be used as warm-ups for more
detailed figure drawings!

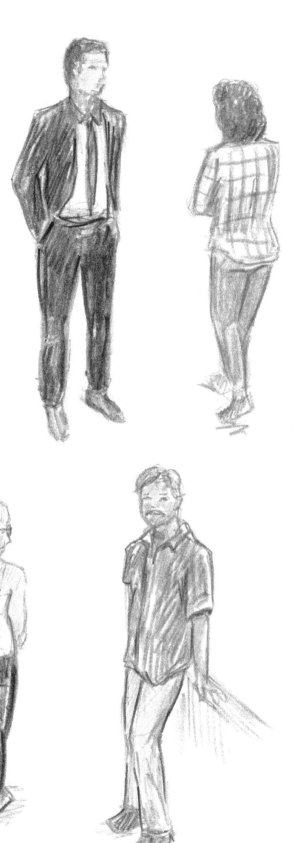

CLOSING THOUGHTS

Regardless of the subject, whether it's a cat sitting in a window or a vase holding a single flower, be patient and take your time. With just a little practice and your favorite colored pencils, you can draw anything you want to!

Use the techniques and projects in this book to get your pencils moving, and then take it to the next level with your own explorations in colored pencil art. Remember that practice makes progress—don't worry about striving for perfection. Have fun and play with your art making. The more you create, the more comfortable you become with your tools—and the more you'll see your own unique style begin to emerge.

ABOUT THE ARTIST

Chelsea Ward is an art teacher and maker of one-of-a-kind creations. Chelsea, who holds a BFA in studio art from the University of Texas at Austin, currently manages her stationery business, Sketchy Notions, and an Etsy shop of custom treasures; teaches art lessons and workshops through Arts Outreach and across the country; hosts art retreats in Tuscany through Wanderful Retreats; and is the head chalk scribbler with Chalk by Chels. Chelsea is the author of *Modern Drawing* and *Your Year in Art* (both from Walter Foster Publishing). She lives in California. www.chelseawardart.com

ALSO AVAILABLE FROM WALTER FOSTER PUBLISHING

978-1-63322-356-1

978-1-63322-492-6

978-1-63322-618-0

978-1-63322-481-0

978-1-63322-810-8

Visit Quarto.com • WalterFoster.com

Printed in the USA
CPSIA information can be obtained
at www.ICGtesting.com
CBHW041427120524
8160CB00004B/6